IMAGES
of Rail

REVISITING THE
LONG ISLAND RAIL ROAD
1925–1975

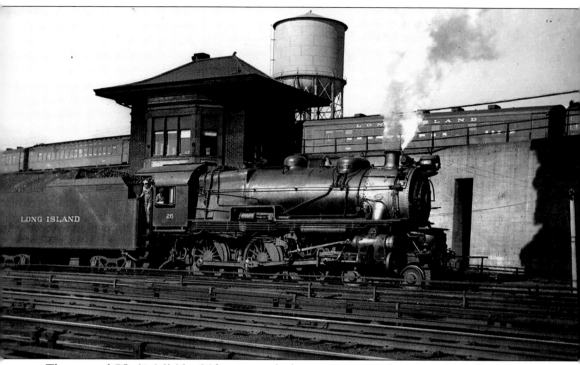

The crew of G5s (4-6-0) No. 26 has just picked up its engine at the Morris Park Shops and is now preparing to leave to pick up its train, perhaps at the Richmond Hill Storage Yard, located on the other side of the Montauk branch embankment seen in this c. 1938 northward view. The crew has stopped at Dunton tower to receive permission from the block operator to proceed. The engine and crew will access the storage yard via concrete tunnels in the embankment visible behind the locomotive. (H. Forsythe Collection, David Keller Archive.)

IMAGES
of Rail

REVISITING THE LONG ISLAND RAIL ROAD
1925–1975

David Keller and Steven Lynch

Copyright © 2005 by David Keller and Steven Lynch
ISBN 978-0-7385-3829-7

Published by Arcadia Publishing
Charleston, South Carolina

Printed in the United States of America

Library of Congress Catalog Card Number: 2005924380

For all general information contact Arcadia Publishing at:
Telephone 843-853-2070
Fax 843-853-0044
E-mail sales@arcadiapublishing.com
For customer service and orders:
Toll-Free 1-888-313-2665

Visit us on the Internet at www.arcadiapublishing.com

Dedicated to all the railroad veterans past and present who through their hard work, dedication, and long hours helped make the Long Island Rail Road great.

—David Keller

Dedicated to my mother and my wife for their encouragement, caring, and presence throughout my life, lighting the way.

—Steven Lynch

Contents

Acknowledgments		6
Introduction		7
1.	Electrified Service	11
2.	Feeding the Firebox	29
3.	Our Diesel Heritage	45
4.	The Freight Business	61
5.	Passenger Service	77
6.	The Morris Park Shops	93
7.	Depots and Towers along the Right-of-Way	113

Acknowledgments

I would like to thank all the terrific people who were so impressed with our first book that they told me they expected to see a second one. Thanks also go to three old friends: Art Huneke for his invaluable tower data; Vincent Seyfried for his equally invaluable station and roster data, as well as the dates of first-year electrification; and Ron Zinn for his detailed Morris Park Shops data and for reviewing chapter 6 for any errors. Credit goes to the late Robert Emery for his outstanding, hand-drawn, and highly detailed system maps of the Long Island Rail Road—the Morris Park Shops in particular. As always, I wish to acknowledge the wonderful photography of George E. Votava, William Lichtenstern, Jeff Winslow, W. J. Edwards, George G. Ayling, James V. Osborne, and Jules P. Krzenski. I am grateful for the generosity of my friend Edward Hermanns. Finally, a special thank-you goes to my wife, Susan, who has always supported me in my life's interest during our 25 years together.

—David Keller

I would like to thank all those who sent words of encouragement on the first book and pushed the implementation of this second volume. A special thank-you goes out to my friend, mentor, and coauthor Dave Keller. Without his archives, none of this would have been possible.

—Steven Lynch

INTRODUCTION

In 2005, the Long Island Rail Road (LIRR) celebrates its 100th anniversary of electrification as a means of moving both freight and passenger traffic on the nation's largest and oldest commuter railroad. Over 700 trains daily, with ridership in excess of 250,000, make the trip into New York City's Pennsylvania Station—made possible via the use of third-rail electrified service.

As before, most of the photographs presented have never before been published, and great care has been taken to provide high-quality images with captions of historical background information to give the reader greater insight into the operations of the LIRR. To that end, we present the following.

Chapter 1, "Electrified Service," celebrates the rich heritage of electrification inherited from the LIRR's parent, the Pennsylvania Railroad (PRR), and the need to enter the long East River tunnels for access to New York City's Penn Station with cost-effective, pollution-free operations.

Chapter 2, "Feeding the Firebox," illustrates the diversity of both passenger and freight operations behind steam until its demise in October 1955.

Chapter 3, "Our Diesel Heritage," covers the introduction of major cost-effective diesels starting in the late 1940s, as the LIRR began to dieselize its aging steam fleet, completing the task by 1955.

Chapter 4, "The Freight Business," focuses on the railroad's freight-hauling and switcher operations, illustrating the "other" Long Island Rail Road. Timeless photographs of LIRR cabooses, freight trains, switching operations, and other facets of good old-time LIRR freight performance are presented.

Chapter 5, "Passenger Service," provides a view of the varied equipment leased and purchased for both everyday commuter use and special occasion operations. MUs, Ping-Pongs, double-deckers, and parlor cars all have a place in LIRR history.

Chapter 6, "The Morris Park Shops," takes the reader behind the scenes into the maintenance of a large fleet of locomotives and passenger cars and gives a tour of the service facilities required of a Class 1 railroad.

Chapter 7, "Depots and Towers along the Right-of-Way," examines a part of daily operations that makes the railroad function, usually unnoticed by the general public, but playing a critical role in the safe daily movement of people and goods over the line.

The authors' intent is that this collection stand alone or be viewed as a continuation of the first book. We hope this volume will enrich the reader's understanding and appreciation of a major force that has shaped Long Island's past historical growth and affected the lives of so many, even to this day.

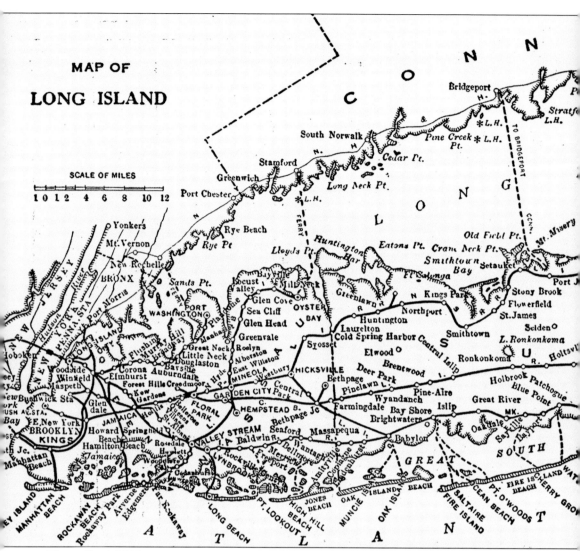

This official LIRR system map was taken from the back of public timetable LI-1, effective September 20, 1936; however, the Rand McNally and Company map has a date of January 1934. It shows the Wading River extension, as well as the Sag Harbor branch, both in use during this

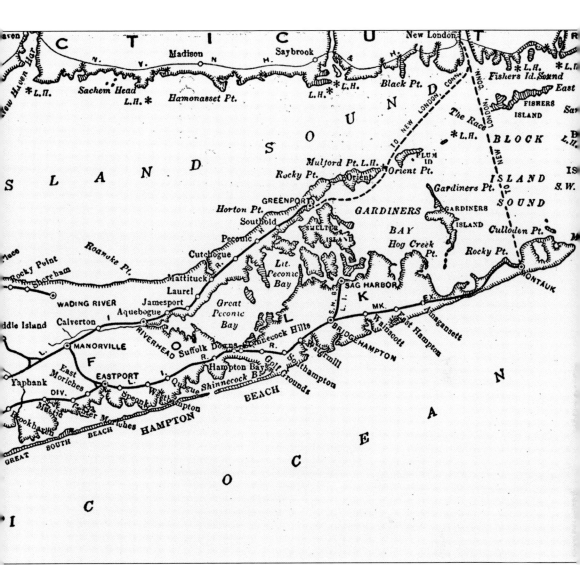

time frame, though it inaccurately shows the Manhattan Beach branch, abandoned in 1924. Curiously, the map had indeed been recently updated, as the Whitestone branch, abandoned in 1932, is not shown. (David Keller Archive.)

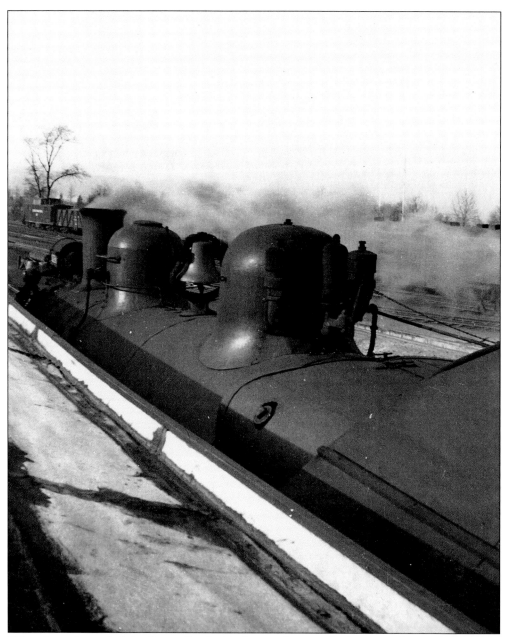

Taken from the roof of the Oyster Bay freight house, this view looks across the top of the boiler of leased Pennsylvania Railroad Atlantic class E3sd (4-4-2) locomotive No. 4176 on a winter's day in early 1941. This closeup shows the steam dome, with the whistle mounted behind. The pull-chain leads from the whistle to the cab for the engineer's use. Visible just below this chain is the ash-pit track. Also seen is the brass bell in its mounting, then the sand dome, the smokestack, the generator, and the headlight. To the left of the headlight is one of the two classification lights that would soon be removed from all Pennsylvania locomotives by PRR edict. Beyond the steaming smokestack, spewing smoke that is covering the passenger cars in the right background, a wooden N52A class caboose lays up on the rear of a freight in the yard. (Photograph by T. Sommer.)

One
ELECTRIFIED SERVICE

Celebrating 100 years (1905–2005) of electrification, the Long Island Rail Road owes much of its success and viability to its parent, the Pennsylvania Railroad. The PRR sought a terminus on Manhattan Island and undertook a massive project in 1903 to meet this need: a four-track main line set of tunnels under the Hudson River; the massive Pennsylvania Station; the four-track tunnels under the East River leading into the world's largest coach storage yard at Sunnyside, Long Island City; and the Hell Gate Bridge yielding access to New England. To accomplish this end, the PRR bought controlling stock in the LIRR and commenced building in 1905.

That year saw intense changes on the LIRR. On July 26, the first electric service was established between Flatbush Avenue, Brooklyn, and Rockaway Park. On August 29, electric service opened from Flatbush Avenue to Jamaica. On October 2, electric service opened to Belmont Park Race Track. Electric service to Queens Village started on November 1. Three days later, the Flatbush Avenue station concluded steam service, and the new depot began operations on November 5. On December 11, electrification spread from Jamaica to Valley Stream.

Pennsylvania Station was completed in June 1910, and on September 8, the first LIRR commuter trains entered the East River tunnels; the Long Island connection to Manhattan was inaugurated. From that point forth, the continued expansion and viability of Long Island's suburban communities was assured.

MP41 cars Nos. 1100 and 1101 perform Mitchell Field shuttle service on the east leg of the wye at Country Life Press, Garden City, in this view looking northeast around 1938. The Central branch extension is visible at the left. These were the first MU (multiple unit) style cars in LIRR service. Built by American Car and Foundry in 1905, they measured 51 feet 4 inches in length. (Photograph by Jeff Winslow.)

Class AA1 electric locomotive No. 323 lays up at the Richmond Hill Storage Yard in March 1937. Built by the Pennsylvania Railroad in 1905 and numbered 10001, this experimental unit was the PRR's first electric locomotive. It was sold to the LIRR in May 1916 and renumbered 323. Nicknamed "Phoebe," it was put into freight and switching service. In July 1937, Phoebe was retired and scrapped. (Photograph by Jeff Winslow.)

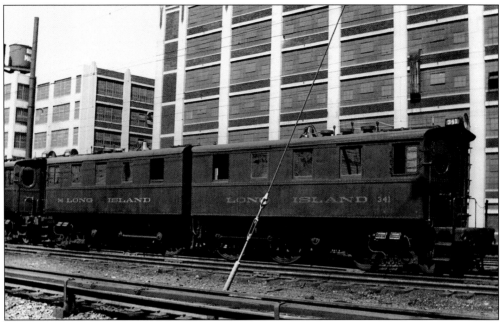

Additional testing and experimentation (some held on the Central Extension in 1908) to develop an efficient electric locomotive that could accommodate passenger and freight service, especially in and out of the soon-to-be-opened Pennsylvania Station in Manhattan, led to the production of the class DD1 in 1909. Here, DD1 No. 341 is pictured at Sunnyside Yard, Long Island City, in April 1934. (Photograph by George E. Votava.)

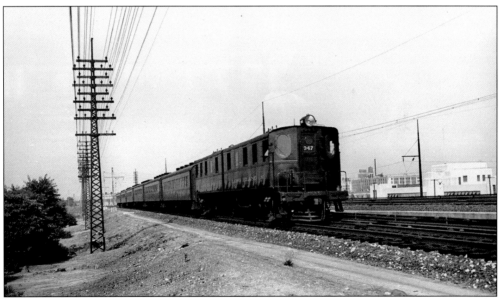

DD1 No. 347, in shiny new paint, deadheads an equipment train eastbound from Pennsylvania Station in Manhattan to Jamaica, passing through Sunnyside, Long Island City, in August 1937. Deadheading indicates a nonrevenue (no passenger) run, and in this case, the DD1 serves the purpose of delivering equipment to a terminal where it will be used as a scheduled train. (Photograph by George E. Votava.)

This eastward view from the Route 231 overpass reveals the huge Babylon electric yard in April 1972. Laying up are the many M1 trains awaiting their next-day rush-hour departure. A year or

two earlier, this yard would have been filled with the old-style MU cars, as well as MU double-deckers. (Photograph by George E. Votava.)

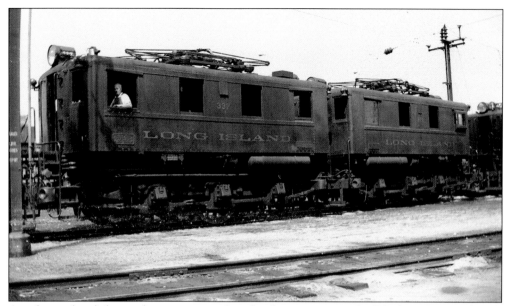

Another style of electric locomotive used in freight service was the B3 class. Equipped with folding pantographs, it got its juice from the overhead catenary wire system. This limited the locomotive's service to the New York Connecting Railroad (former Bay Ridge branch) and areas of Long Island City. Here, No. 337, with its engineer, and No. 328 are seen at Bay Ridge, Brooklyn, in July 1938. (Photograph by George E. Votava.)

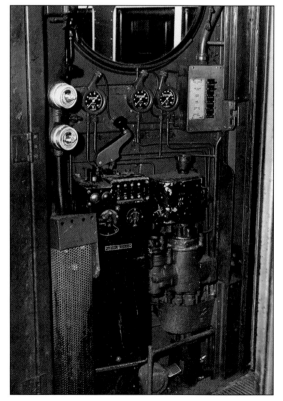

The motorman's cramped quarters of a class MP72c MU cab held the various equipment required to operate the car, as evidenced in this 1957 image. The owl's-eye window is visible above the air brake gauges. At the right are the various light switches. Directly under the air brake gauges is the controller handle. Various air lines are routed around the cab. (Photograph by Jules P. Krzenski.)

A three-car double-decker train sits at the newer station platforms of Belmont Racetrack in Elmont, New York, in 1963. The racetrack is visible in the background. This spur branched off the main line just east of Queens Village and first provided service to the track in 1905. The original station's covered platforms were razed in 1957, when the tracks were cut back to north of the Hempstead Turnpike. (Photograph by W. J. Edwards.)

A two-car MU train is eastbound at the Valley Stream station in 1967. Notable in this early grade elimination project are the LIRR keystone logos on either side of the station name. The towerlike structure at platform level is the baggage elevator, used to transport baggage checked at the ground-floor ticket office up to the track. (Photograph by David Keller.)

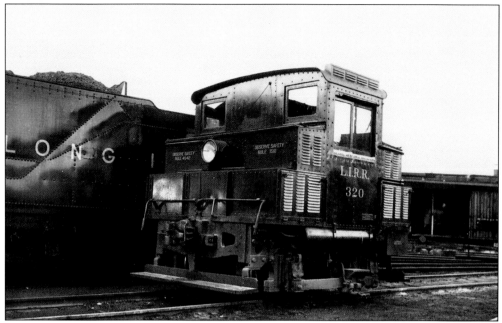

Class A1 electric shop switcher No. 320 was used to move equipment around the Morris Park Shops. Built by Baldwin-Westinghouse in 1927, this tiny locomotive lays up on one of the tracks extending from the turntable in August 1940. Part of the roundhouse is visible in the background, as is the Futura lettering on the locomotive tender. No. 320 was withdrawn from service in December 1958. (H. Forsythe Collection, David Keller Archive.)

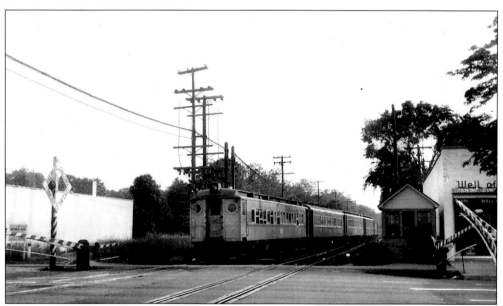

An MU train heads west from Hempstead toward the Garden City station, after having crossed over Franklin Avenue. At the left is the wooden diamond crossing sign. Garden cabin is at the right, tight up against the store wall and protecting the crossing with manually operated gates. The train, traveling on the crossover switches accessing the westbound track, approaches the station in this 1956 view. (Photograph by W. J. Edwards.)

A brand-new string of M1 cars is stopped at the Shea Stadium station at Flushing Meadows, Queens, in this 1969 view. Originally the site of an ash dump, the surrounding area was used to host the 1939–1940 and 1964–1965 New York World's Fairs. Shea Stadium was built here to house the New York Mets, and this station was used for the ballpark after the fair closed. (David Keller Archive.)

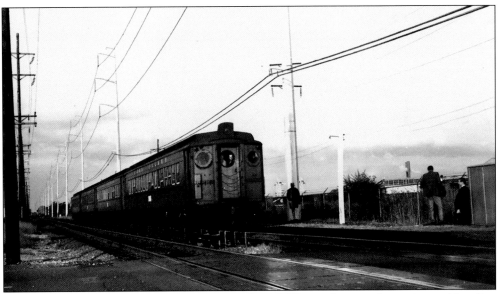

Looking east at Landia in 1970, this view reveals an MU train leaving the station and heading for the new end of electrified territory at Huntington. Originally opened in 1951 for employees of Circle Wire, the station continued in use years later after the company's name was changed to Cerro Wire. The low platforms, on alternating sides of Robbins Lane, were removed on October 3, 1973. (Photograph by W. J. Edwards.)

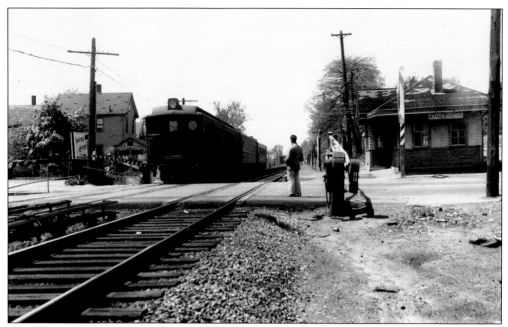

A three-car MU train led by a Railway Express Agency (REA) car heads east over the Linden Boulevard crossing at Cedar Manor in 1954. Located on the Atlantic branch and opened in 1906, this little depot was razed in February 1959 and the station stop discontinued with the grade elimination through here. (Photograph by W. J. Edwards.)

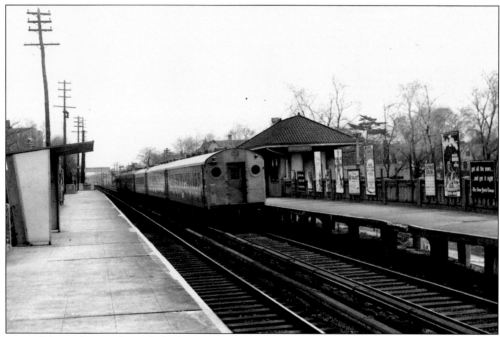

Viewed from the westbound platform, an eastbound MU train leaves the Broadway station in Flushing, bound for Port Washington, in 1954. Opened in 1906, the station and platforms were elevated during 1912–1913. (Photograph by W. J. Edwards.)

Looking east toward the 149th Place overpass and the Murray Hill depot beyond, this view shows an MU train heading west at the station in 1950. Opened in July 1914, the station platforms were built into the concrete embankment walls with safety openings every several feet to allow trackmen to stand clear of passing trains. The depot building spanning the tracks was razed in 1964. (Photograph by W. J. Edwards.)

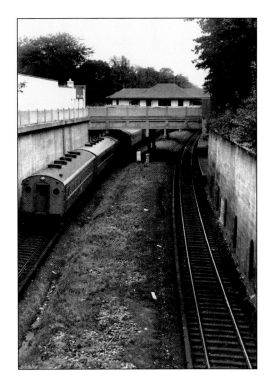

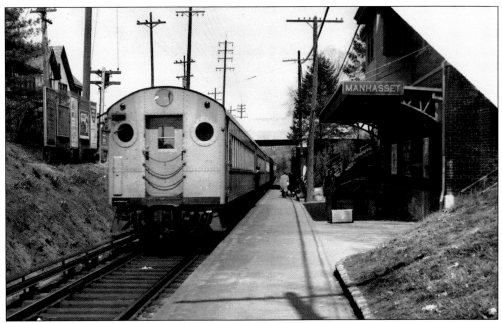

The trainman ensures that all passengers are clear of the train as this MU prepares to depart the Manhasset station, eastbound for Port Washington, in 1954. The substantial depot building was opened in 1925, with the ticket office and waiting room at street level. (Photograph by W. J. Edwards.)

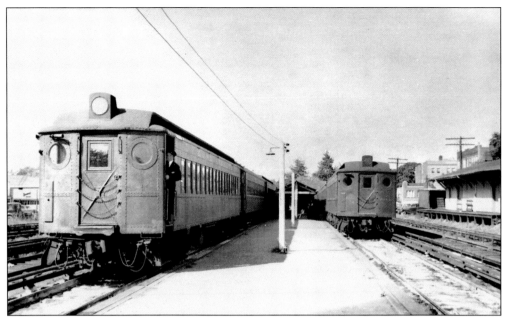

It is a bright, sunny day at the Port Washington terminal in 1944. Taken from the low platforms and looking east toward the depot, this photograph shows two MU trains laying up. The train at the left appears ready to depart, with a trainman standing on the closed trap and conversing with the motorman. At the far right is the freight house. (Photograph by W. J. Edwards.)

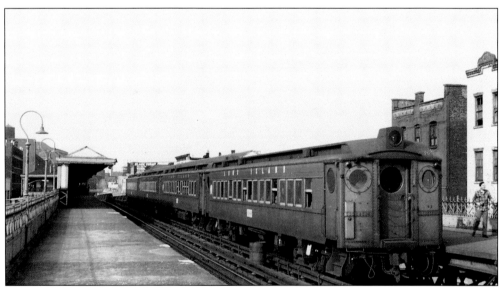

This MU train heads west at the Nostrand Avenue, Brooklyn, station in 1960. The elevated structure opened in August 1905 and, at the time of the photograph, still sported the fancy goose-neck platform lights and the decorative ornamental handrails, visible at the far left and far right. (Photograph by W. J. Edwards.)

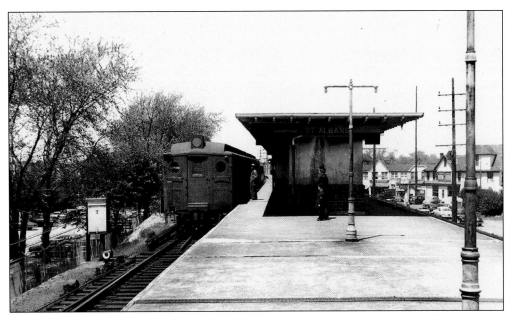

A Railway Post Office (RPO) car leads this eastbound MU train as it approaches the St. Albans station in 1954. A mother and child await the train. At the left is a box housing the LIRR crew telephone. In front of it is an old, low, switch target. The business district is visible in the right background. (Photograph by W. J. Edwards.)

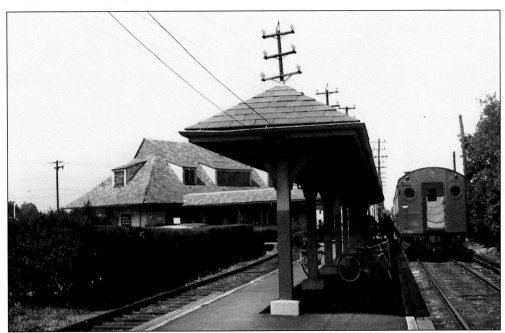

An MU train discharges passengers at the platform of the West Hempstead station in 1950. The old depot building at the left was built in 1928 on the north side of the Hempstead Turnpike. It was moved south to this location and placed in service in September 1935 to eliminate blocking the busy thoroughfares at train time. The depot was destroyed by fire in 1959. (Photograph by W. J. Edwards.)

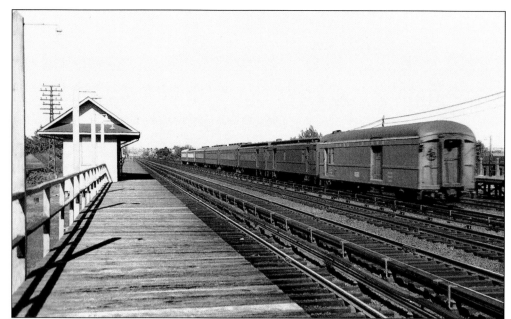

Racing along westbound on the express tracks, this MU train passes through Rego Park around 1952. This westward view shows the train with two RPO/REA cars in tow. Rego Park was located along the Main Line but was a station stop only for trains servicing the Rockaway Beach branch. The structure was razed in November 1958, and Rego Park was discontinued as a stop in June 1962. (Photograph by W. J. Edwards.)

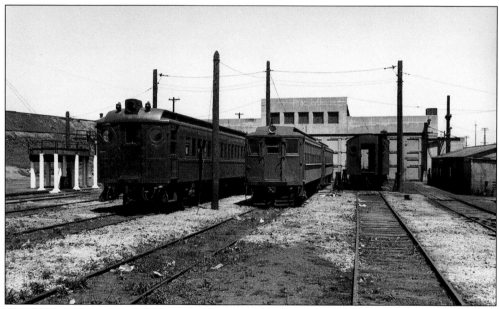

The 1906-era inspection shed at the Dunton Electric Car Shops hosts a selection of early MU equipment. At the left, looking eastward in this 1940 view, is class MP54 motor No. 1438, built in 1908. In the center, MP41 motor No. 1001, built in 1905, was one of the first electric cars used in LIRR service. To the right is class T54A trailer No. 983, built in 1917. (Photograph by George E. Votava.)

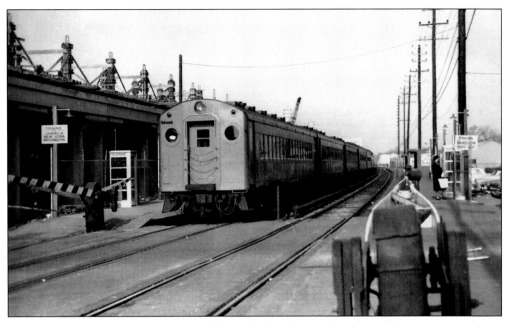

The grade elimination progresses swiftly in the background as this MU train passes by on the westbound temporary track at Freeport in 1960. In the foreground are the hand-operated crossing gates with shiny crank handles. The temporary low-level platform is to the left of the train, and a shelter shed can be seen on the eastbound platform at the right. The new station opened in 1961. (David Keller Archive.)

After the LIRR's last MP41 class MU cars were retired from Mitchell Field shuttle service, they were replaced with two MP54 class MU cars. In this 1949 northeastward view, No. 1762 and No. 1943 lay up north of the station at Country Life Press, Garden City. This track once crossed the Central extension at Hempstead Crossing, a short distance beyond the left of the photograph, and continued to Mineola. (Photograph by W. J. Edwards.)

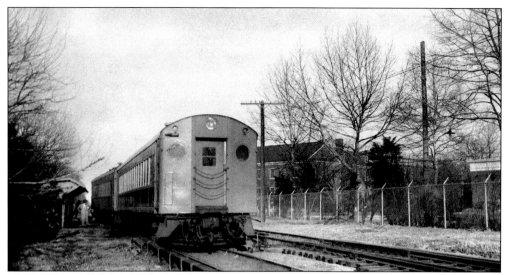

This photograph, taken at the Mitchell Field station, provides another view of the shuttle in its last years. The station was used to service the air base located there. In this 1950 eastward view, the old wooden shelter shed stands to the left of the two-car train. All shuttle passenger service would end on this branch on May 15, 1953. (Photograph by W. J. Edwards.)

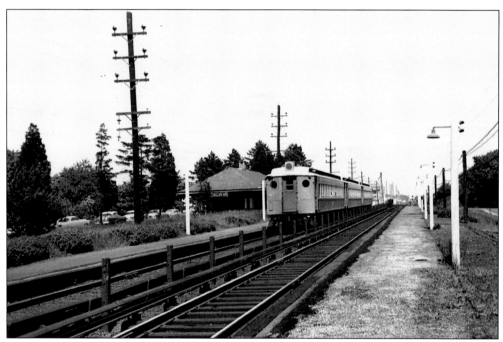

A westbound MU train in the Tichy color scheme passes the Merillon Avenue, New Hyde Park, station in 1954. In this scene looking east, the remains of the decorative shrubs are visible amongst the weeds along the edge of the westbound low platform. Built in 1912, this beautiful station was razed in 1958 and replaced in April of that year by a small brick and block structure. (Photograph by W. J. Edwards.)

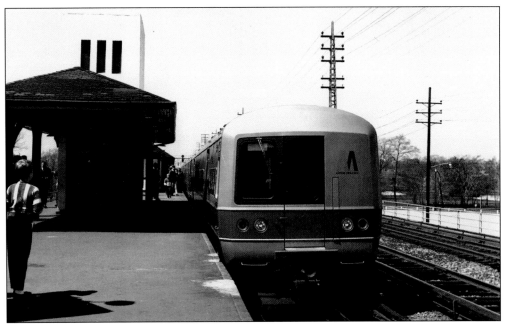

When the Budd M1 Metropolitan electric cars first saw service on the LIRR, they were an eye-catcher. Several display sites were located at outlying stations, where the curious could climb into and inspect a set of cars. This view, looking west at Valley Stream on April 20, 1969, shows a new M1 train being run as a railfan extra. The tower above the platform was the baggage elevator. (David Keller Archive.)

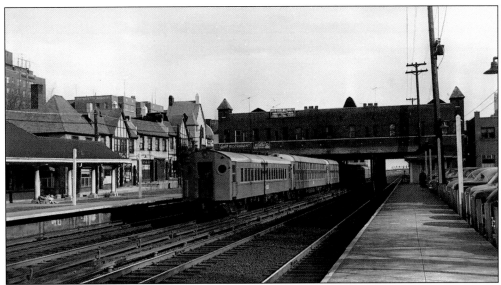

On this cold winter's day around 1955, an MU train in the Tichy color scheme emerges westbound on the express track from under the Lefferts Boulevard overpass, passing through Kew Gardens. The train has two double-decker cars that appear to have just squeezed under the overpass. At the left is the depot. On the platform at the right is the enclosed eastbound waiting room. (Photograph by W. J. Edwards.)

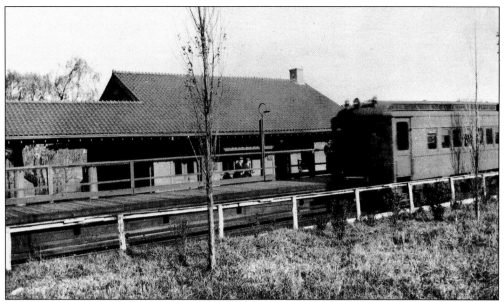

A westbound MU train enters Malba station in this c. 1925 scene. The station, built in 1908–1909 on the Whitestone branch, north of the tracks and west of Malba Drive (144th Street), was named with an acronym from the initials of the five original developers who bought the surrounding properties and incorporated the Malba Association in 1908. Electrified in 1912, the branch was abandoned in 1932. (Photograph by James V. Osborne.)

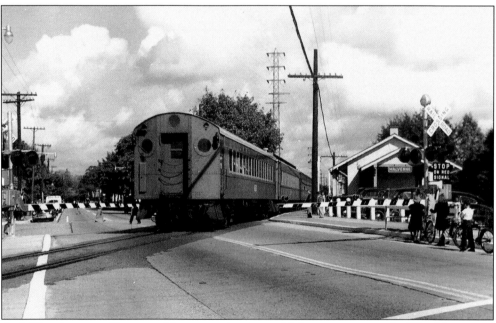

An MU train crosses Hempstead Avenue and arrives at Malverne station on the West Hempstead branch on this summer's day in 1954. Children with bicycles patiently wait for the gates to rise. Malverne depot was opened in February 1913; the West Hempstead branch originally connected Valley Stream with Country Life Press and Mineola. (Photograph by W. J. Edwards.)

Two

FEEDING THE FIREBOX

As the largest commuter Class 1 railroad in the world, the Long Island Rail Road had steam—and plenty of it. Additionally, the size of the fleet required the needed support facilities in place to repair, upgrade, and maintain this large number of engines. The parent Pennsylvania Railroad met demand by designing and manufacturing most of its locomotives at its own shops and, as a result, was able to lease hundreds of engines of varying classes to the LIRR up to and ending in 1951, due to the volume of Long Island traffic. The said volume increased dramatically during the years of World War II, as a result of troop trains to and from Camp Upton in Yaphank, plus increased freight activity to and from the aircraft and defense plants on the island. Because of increased war demand, these classes included not only switcher types, but additional long-haul passenger locomotives such as the K4s Pacific and the massive L1s Mikado freight engines, which saw LIRR service on the western end of the island only during the war years.

This chapter provides a look at steam in its various facets: switching in the yards, hauling freight along the line, and speeding the hundreds of thousands of commuters to Jamaica and Long Island City to make their connections to work in New York City, Brooklyn, and Queens.

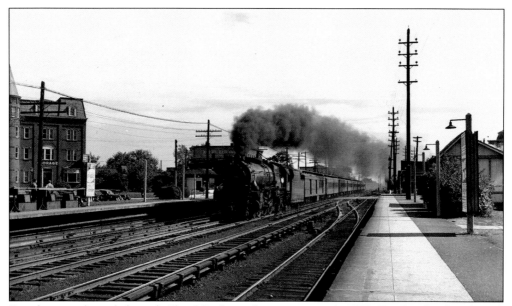

Barreling westbound through Floral Park on the express track, PRR K4s Pacific class (4-6-2) No. 5406 pulls Montauk train No. 27 in September 1948. In the lead is an RPO car. The tracks running along the platform at the right curve off beyond the grade crossing for the Hempstead branch. Covered in smoke in the distance is Park tower. (Photograph by George E. Votava.)

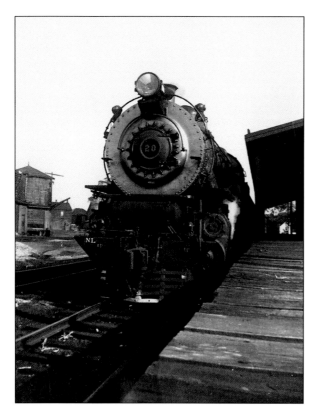

Looking east from the Oyster Bay freight house platform in 1940, this view shows locomotive class G5s (4-6-0) No. 20 laying up. The "NL" stenciled on its pilot means the locomotive was to be used in the Pennsylvania Railroad's New York region, Long Island zone. In the left background is the old, squat water tower with suspended spout. (Photograph by T. Sommer.)

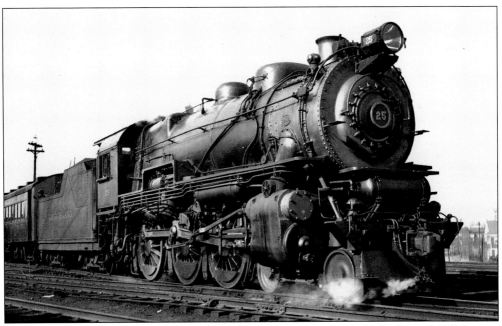

In this clear, well-lit photograph, G5s No. 25 lays up with its train in the Richmond Hill Storage Yard on a cold, crisp January day in 1937. The locomotive sports a low-sided tender. (David Keller Archive.)

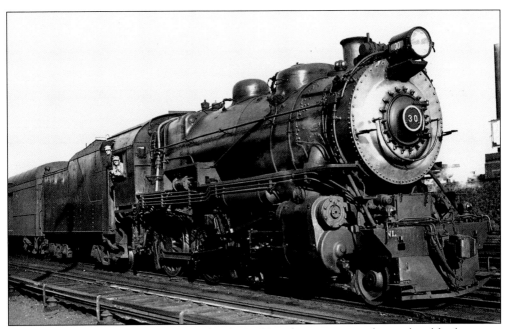

Also in the Richmond Hill Storage Yard, G5s No. 30 and its train await the go-ahead for departure in May 1937. The engineer leans out the cab window, and his fireman stands on the deck. This locomotive includes a high-sided tender. In the right background is the embankment of the Montauk branch, and beyond it is the smokestack of Sheffield Farms. (David Keller Archive.)

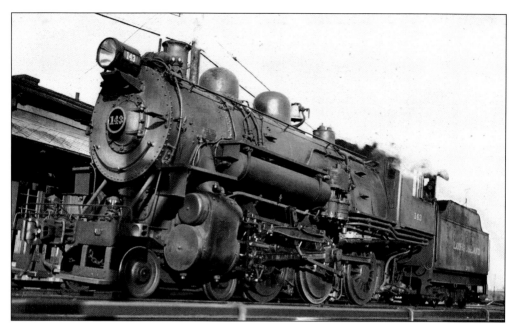

In front of the trainmen's building at the Richmond Hill Storage Yard in November 1936 is G53sd (4-6-0) No. 143. The fireman leans out his side of the cab and watches the photographer. A tower was added to the top of the building in 1945, becoming the yardmaster's office. (David Keller Archive.)

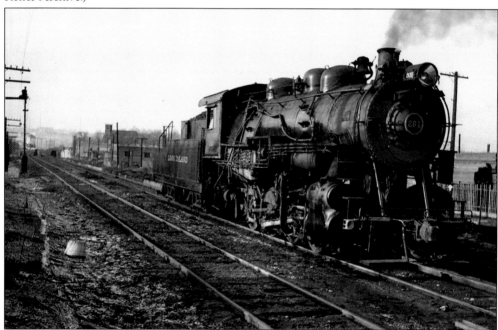

Sooty snow is on the ground at Maspeth on a winter's day around 1946. C51sa (0-8-0) freight switcher No. 261, sloped-back tender filled with coal, is running light, westbound, in reverse. No. 261 has just helped push a freight up the steep 1.7 percent grade of Mount Olivet and is heading for the lay-up yard indicatted by the water tower in the left background. There the locomotive will await its next helper move. (Photograph by Rolf Schneider.)

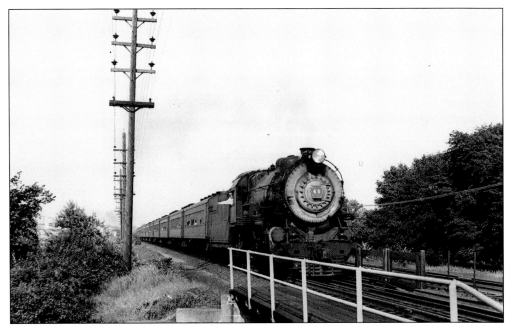

It is a hot, sunny day in July 1947, as evidenced by all the open windows on train No. 4619, allowing the passengers some cooler air. On the head end, G5s No. 40 pulls into Merillon Avenue station in New Hyde Park. The engineer leans out his cab window and gives the photographer a hearty wave. (Photograph by George E. Votava.)

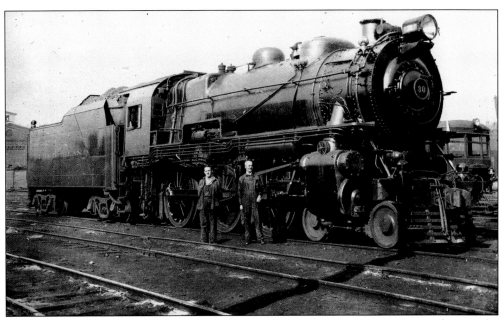

Recently built, newly arrived, and sporting a shiny smoke box is G5s No. 30, seen here at the Morris Park Shops in 1928. Posing proudly next to the new engine are fireman Bill Aha (left) and engineer Ferdinand Shiertcliff. In the right background is the LIRR doodlebug No. 1134, the self-propelled, gasoline-powered railcar used in shuttle service to Sag Harbor. (Photograph by Jefferson I. Skinner.)

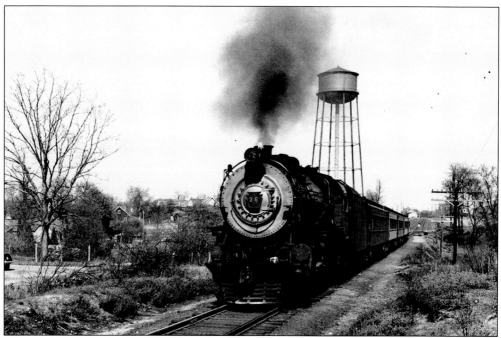

G5s No. 36 has just left Kings Park station, visible in the background along with the town water tower, and is heading west with weekend train No. 4615 from Kings Park State Hospital in May 1947. The LIRR provided passenger service to the state hospitals on Long Island, carrying Sunday visitors and delivering carloads of coal for heating and power. (Photograph by George E. Votava.)

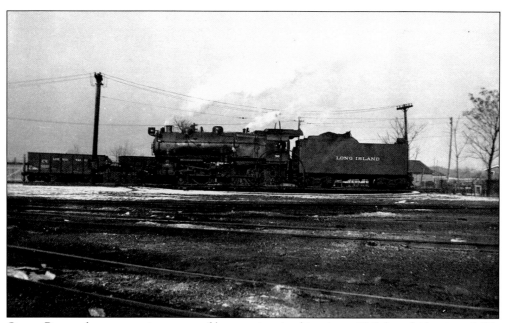

Oyster Bay yard appears quite empty of locomotives in this winter 1941 broadside view of G5s No. 38 after it has just spun around on the turntable. In the background are a couple of Lehigh Valley Railroad hopper cars. (Photograph by T. Sommer.)

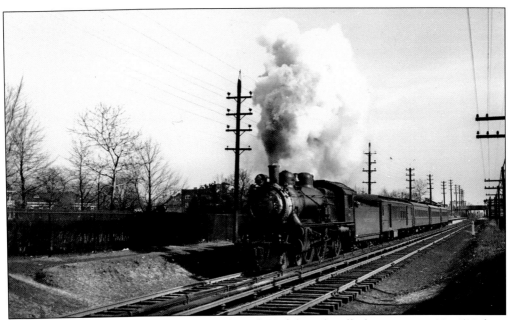

It is a cool February day in 1937 as PRR-leased E3sd (4-4-2) pulls four-car train No. 529 from Oyster Bay westbound through Mineola. The REA-RPO car and three passenger coaches have just cleared the Mineola station platform. This old locomotive was built by the Pennsylvania Railroad's shops in 1904 and used in LIRR service for several years. Originally classed E3d, it was re-classed E3sd after undergoing superheating conversion. (Photograph by George E. Votava.)

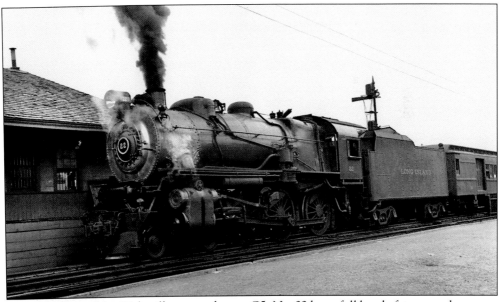

Sitting in front of the Hicksville express house, G5s No. 22 has a full head of steam and prepares to head westbound in July 1937. At the left is the express house, and hovering over the tender is the semaphore block signal indicating "stop." It is a hot day, as evidenced by the open windows in the combine car. (Photograph by George E. Votava.)

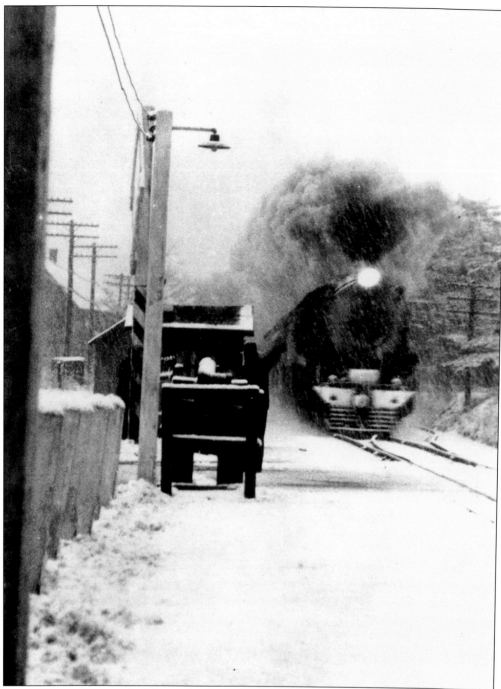

This 1933 scene is typical of the onslaught of Long Island winters. A class G5s locomotive, with wet snow adhering to and highlighting its pilot, pulls its train at speed through the driving snow as it prepares to cross Carleton Avenue in Central Islip. Beyond the old platform lamp and visible to the left is the diamond crossing sign. The wooden pole gates are down, and the crossing guard is waving at the engineer. Beyond him is the shanty where he will soon warm up in front of the glowing potbellied stove. (Photograph by George G. Ayling.)

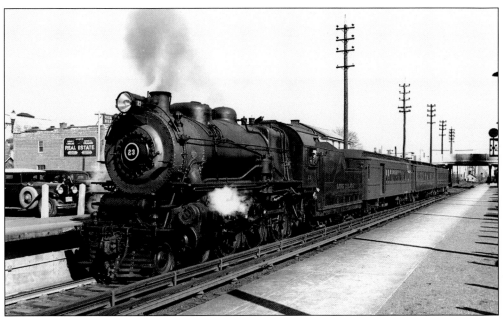

On a bright, crisp February day in 1937, G5s No. 23 and three-car Port Jefferson train No. 627 head westbound at Mineola station. The fireman leans out his cab window, peering at the photographer from behind his partial fold-out windscreen. At the far right is a position light block signal. Beyond it is the soot-encrusted Mineola Boulevard overpass. (Photograph by George E. Votava.)

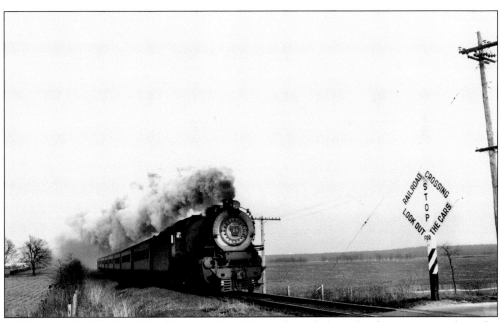

In March 1947, G5s No. 26 pulls train No. 4615 westbound through what appears to be miles and miles of endless farmland in rural Huntington. The tight, billowed smoke, indicative of the cold temperature of the day, envelops the train. At the right is one of the many diamond-shaped protection signs seen all over the island at most crossings. (George E. Votava Collection.)

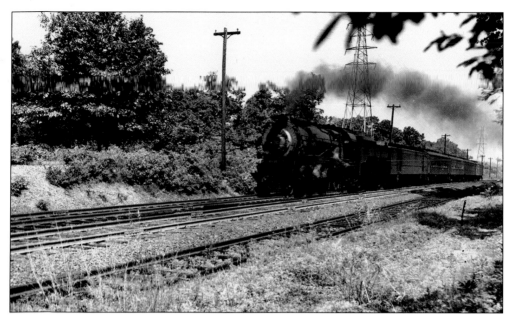

Another hot, humid Long Island day in July 1948 finds G5s No. 26 pulling Oyster Bay train No. 4527 westbound through Albertson. Condensation has formed along the tender's side, almost giving it the appearance of a two-toned paint scheme. (George E. Votava Collection.)

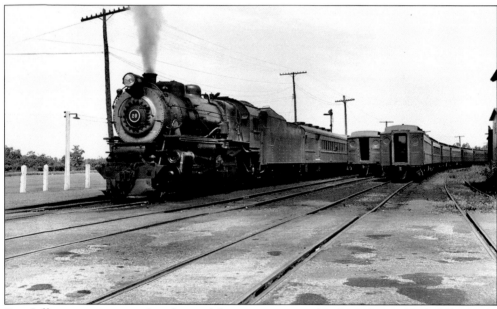

Port Jefferson station is rather deserted for train time on this June day in 1940. G5s No. 28 lays up with its train at the platform, ready to head westbound. Visible above the combine car behind the tender is the semaphore arm block signal. When trains serviced Wading River prior to October 1938, this signal once had two blades mounted on the mast. (Photograph by George E. Votava.)

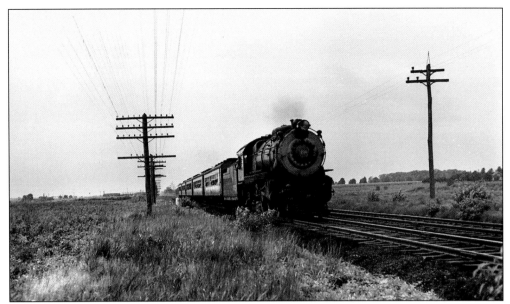

Acres of empty field and farmland surround PRR-leased E6s (4-4-2) No. 230 as it pulls Saturday-only train No. 236 eastbound through Hicksville, headed for Ronkonkoma, in July 1937. The engineer leans out the window for a breath of air, and most of the car windows are open. Condensation has formed along the side of the tender, and the summer haze encompasses everything. (Photograph by George E. Votava.)

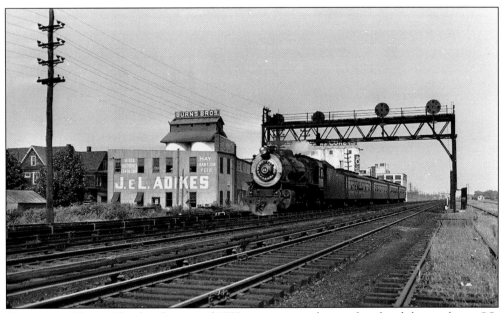

Some typical Long Island industries of 1937 are seen on the north side of the tracks as G5s No. 31 pulls train No. 631 from Port Jefferson through Hillside on a hot September's day. The fireman's cab door is open, as are many car windows. An overhead signal bridge bears position light signals controlling the four-tracked main, and Holban Yard appears to the right. (Photograph by George E. Votava.)

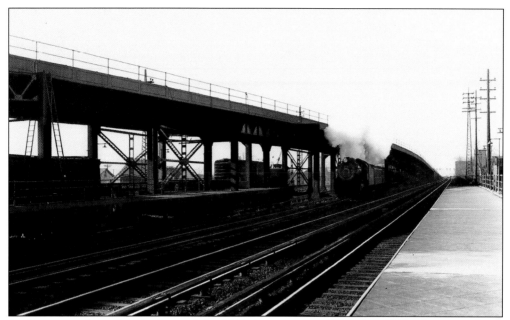

Looking west from the platform of the Hillside station in December 1948, this view shows G5s No. 33 with a full head of steam and train No. 4228 in tow, blasting its way out from under the elevated tracks of the Montauk branch. Visible behind the opposite platform, one of the new diesels pulls a westbound freight train. This area was once known as Rockaway Junction. (George E. Votava Collection.)

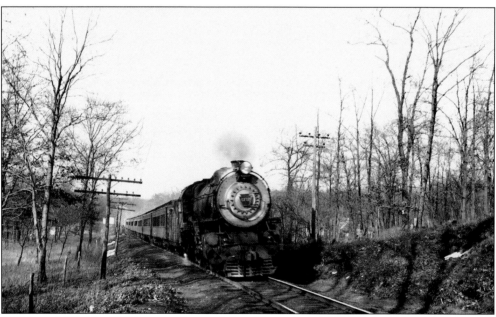

PRR-leased G5s No. 5717 has just departed the old, wooden Cold Spring Harbor station and is heading west through the barren woods with eight-car train No. 4615 in early March 1947. The following year, the residents would have a brand-new depot, and No. 5717 would soon leave Long Island, being sold for scrap in August 1949. (George E. Votava Collection.)

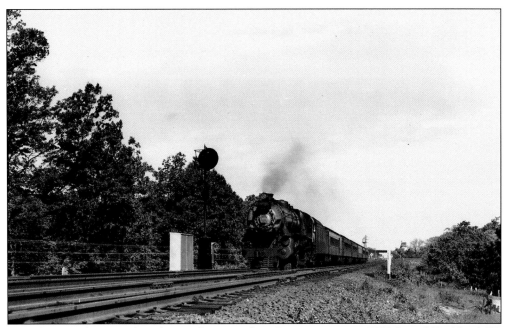

The photographer, standing diagonally across from B tower, captures PRR-leased K4s No. 3655, with recent "facelift," leading a train eastbound through Bethpage Junction around 1947. In the distant background are the overpass of the Long Island Motor Parkway and the diamond crossing signs of the grade crossing of Central Park Avenue. (George E. Votava Collection.)

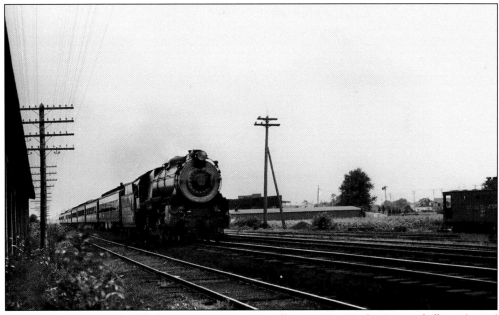

The early evening sun backlights K4s No. 3741 as it pulls train No. 20, the *Cannonball*, eastbound through Hicksville in July 1937. Behind the locomotive and tender are the Pennsylvania Railroad parlor cars. At the far right, wooden snowplow No. 191 lays up in Hicksville yard. (Photograph by George E. Votava.)

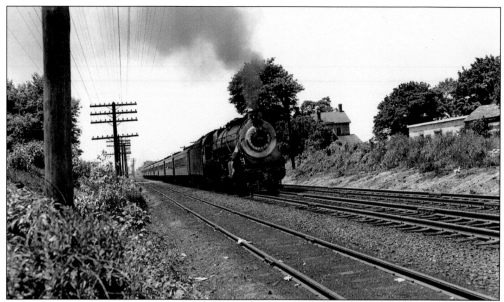

On another hot day, K4s No. 3754 leads Sunday-only train No. 4230 eastbound through Westbury, headed for Ronkonkoma, in June 1947. Here, the K4s has not yet had a "facelift" to switch its headlight and generator locations, install a smaller headlight, and add a platform across the front of the smoke box. The locomotive is, however, sporting a bright silver-painted smoke box with a black door. (Photograph by George E. Votava.)

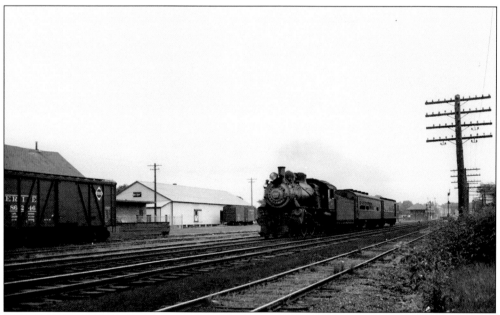

PRR E3sd No. 2985 deadheads a two-car extra train westbound for Jamaica at Hicksville on this July day in 1937. In the distance, the old wooden express house and semaphore block signals are visible. At the left is an old, wooden, exterior-framed Erie boxcar at the freight house, and beyond it is one of many produce houses standing along the right-of-way. (Photograph by George E. Votava.)

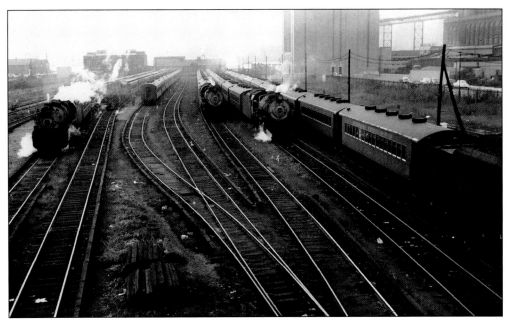

The Long Island City passenger yard appears here in 1950. This hazy westward view reveals, from left to right and coupled with their respective trains, K4s No. 3887, an unidentified K4s, a train without a locomotive, G5s No. 33, G5s No. 32, and a train with only its tender visible. In the center background stands the terminal building, and in the right background is the PRR's 1906 power plant. (Photograph by W. J. Edwards.)

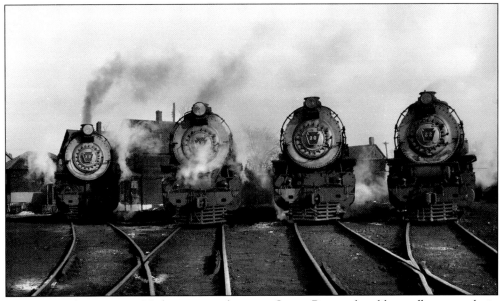

Presenting a fine quartet, G5s locomotives lay up at Oyster Bay on the old roundhouse tracks in February 1948. (The roundhouse was removed in 1929.) Pictured from left to right are No. 39, No. 45 (behind a small cloud of escaping steam), No. 30, and No. 22. All fired up, they await engine crews to couple them to their respective commuter trains. (George E. Votava Collection.)

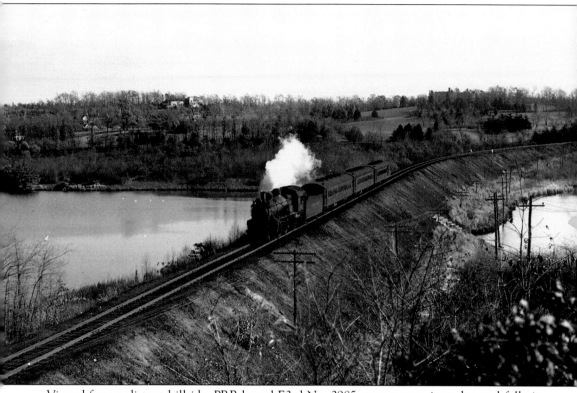

Viewed from a distant hillside, PRR-leased E3sd No. 2985 steams away into the cool fall air while pulling a three-car train westbound on the embankment after departing the station at Mill Neck in November 1940. This scene looking east reveals the rural panorama of the community, as well as Beaver Dam Pond, which is cut in two by the railroad but connected by a stone-framed culvert, visible to the right of the embankment by the water. (Photograph by George E. Votava.)

Three

OUR DIESEL HERITAGE

Diesels were first introduced on the Long Island Rail Road in 1925 in the guise of an Ingersoll-Rand demonstrator unit, followed the same year by box cab No. 401. In 1926, box cab No. 402:1 began service for a very short time. And 1928 marked the arrival of box cabs No. 403A and B, nicknamed "Mike and Ike."

Major dieselization started in earnest, with the ultimate goal of replacing the steam fleet, in 1945. Far more energy efficient, less costly to repair, and not requiring large quantities of coal and water, the diesel soon eclipsed the 100-plus-year reign of the steam engine in less than a decade. Not readily accepted by old-time steam engine crews, the diesel was nonetheless here to stay and became a serious item with which to be reckoned.

Early units included Alco S-1 and S-2 models for yard work, RS models for road-switching freight and commuter runs, and Baldwin VO model freight switchers and DS4 models for both freight and commuter runs. Fairbanks-Morse CPA models appeared in 1950 for passenger service, followed in 1951 by stronger CPA passenger models and Fairbanks-Morse H16 models for both freight and commuter runs.

By the end of October 1955, the diesels had replaced all steam engines, and the LIRR had settled largely on Alco, Baldwin, and Fairbanks-Morse for its major fleet requirements. The old-time engine crews now had no choice but to deal with "progress."

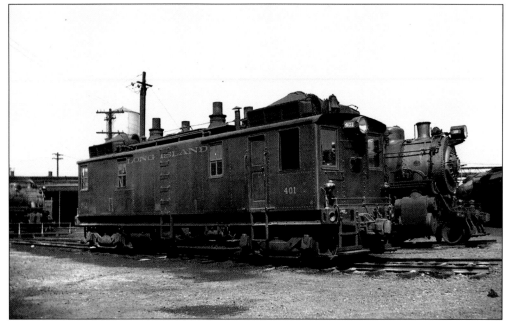

Early attempts at manufacturing a functioning diesel locomotive wound up in the design and production of the oil-electric box cab. Classed AA2, box cab No. 401 lays up on one of the turntable garden tracks at the Morris Park Shops in August 1939. A G5s is on the turntable, and H10s No. 118 is adjacent to the oil-electric. The 401 was built in November 1925 by Alco/GE/Ingersoll-Rand. (David Keller Archive.)

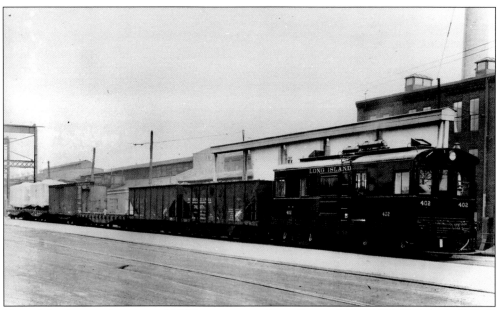

One of the shortest durations of LIRR service was that of box cab No. 402:1. Built by J. G. Brill in January 1926, it had twin gasoline engines and was classed AA3. After a two-week trial, it was returned to Brill. Here, the box cab is lettered for the LIRR but pulls a freight train in Philadelphia when still brand new. (George E. Votava Collection.)

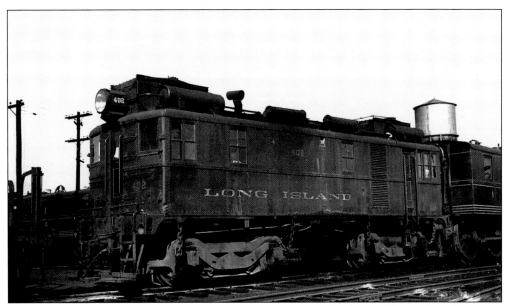

The second No. 402 was a September 1928 product of Alco/GE/Ingersoll-Rand, and its track record in LIRR service was better than its predecessor. Classed AA3, this oil-electric lays up behind a DD1 electric locomotive at the Morris Park Shops in November 1940. Used in local freight service, the 402:2 was finally retired in June 1951. (David Keller Archive.)

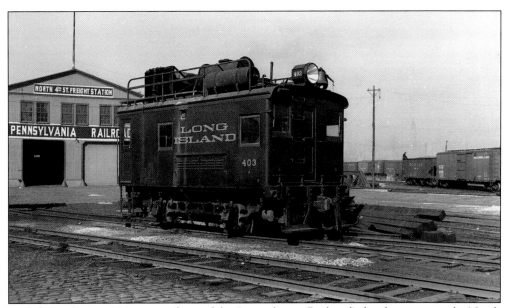

Little box cab No. 403A rests in front of the Pennsylvania Railroad's freight station at the North Fourth Street yard in Brooklyn around 1937. Built by Baldwin-Westinghouse in January 1928, this unit was classed AA4 and nicknamed "Mike." It lasted in LIRR freight service with B-unit "Ike" until June 1945, when it was retired and sold. (Photograph by Jeff Winslow.)

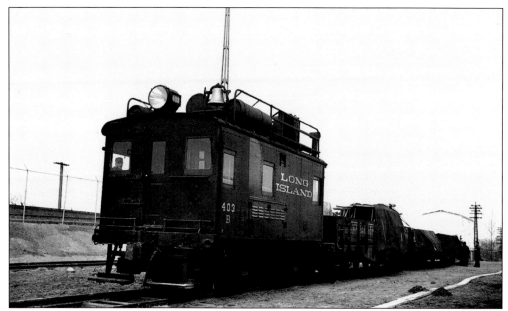

"Ike," the other half of the No. 403A-B box cab set, pulls a special freight train on the grounds of the New York World's Fair at Flushing Meadows in 1939. Whatever the load is, it is heavily tarped. The 403B was also built by Baldwin-Westinghouse in January 1928 and retired at the same time as the A unit. (Photograph by Jeff Winslow.)

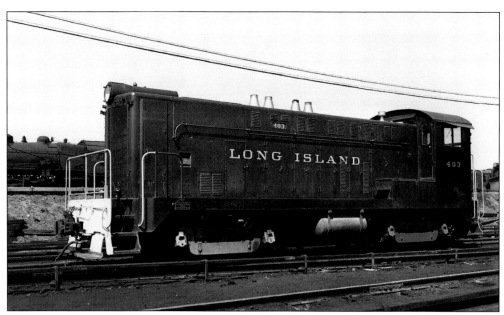

It would be 17 years before the LIRR purchased more diesel locomotives for road use. Baldwin model VO-660 No. 403 was one such unit. Built in September 1945, it was soon placed in LIRR service. Here, in April 1950, it lays up at the Morris Park Shops with an H10s locomotive in the background. This 660-horsepower unit was sold in November 1963. (Photograph by George E. Votava.)

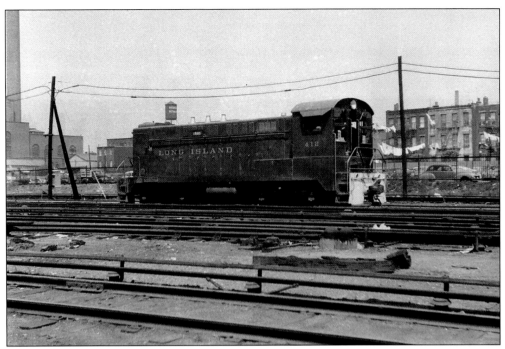

Another early Baldwin product was the model DS4-4-660, built in May 1948. No. 412 is seen here at the Long Island City passenger yard in 1951. At the left is a smokestack of the PRR power plant. At the right are tenements with laundry hanging out to dry. The 412, also equipped with 660 horsepower, was sold in February 1964 and scrapped. (David Keller Archive.)

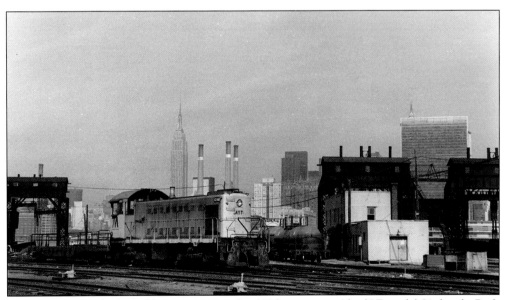

Contemporary with the Baldwin units were the 660-horsepower Alco/GE model S1 diesels. Built in June 1946, No. 407, in the MTA color scheme of blue and yellow, lays up with an idler car at the Long Island City float docks in September 1972. In this view, looking west toward the Manhattan skyline, the Empire State Building is visible behind the locomotive. (David Keller Archive.)

49

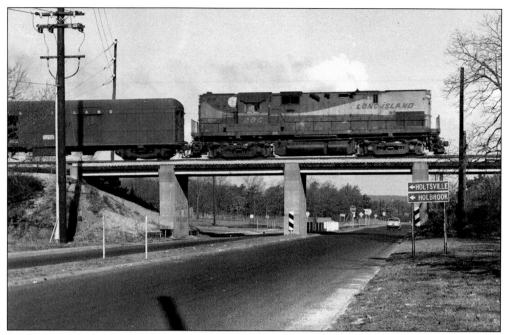

Looking north at the trestle over North Ocean Avenue east of Holtsville, this view shows Alco C420 No. 206 pulling train No. 204 eastbound for Greenport in January 1970. The lead car, a baggage unit, carries newspapers to throw off at stations along the way. Despite the cold temperature, the second door is partway open to prepare for the upcoming stop at Medford. (Photograph by David Keller.)

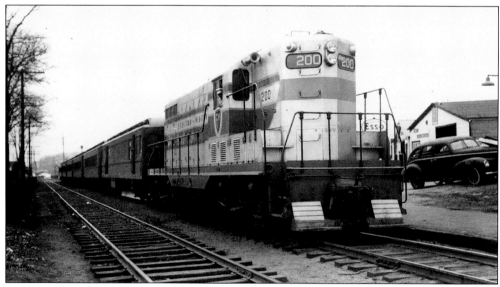

In 1950, when the LIRR was planning on purchasing additional diesels, several manufacturers provided demonstrators for trial runs. Here, EMD model GP7 demonstrator No. 200 leads an LIRR train eastbound at Huntington station. This unit, built in November 1949, was in LIRR trial service from March 27 to April 10, 1950. It later became Chicago and North Western No. 1519. The LIRR opted to purchase Fairbanks-Morse units instead. (Photograph by W. J. Edwards.)

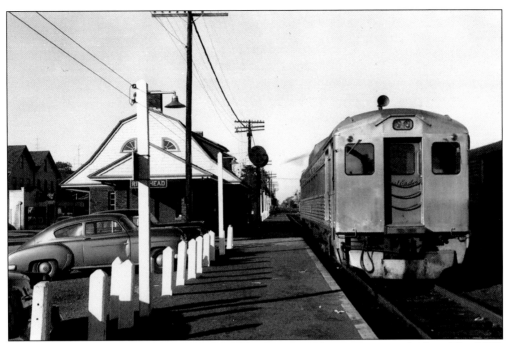

The Budd Rail Diesel Car (RDC) was ideal for lines with low passenger ridership. The LIRR purchased two units—RDC1 No. 3101 and RDC2 No. 3121—with ideas of acquiring more. Here, RDC2, complete with baggage compartment, heads eastbound at Riverhead station in early-morning *East Ender* service to Greenport in 1956. The name is painted in script on the orange end door of the stainless-steel car. (Photograph by W. J. Edwards.)

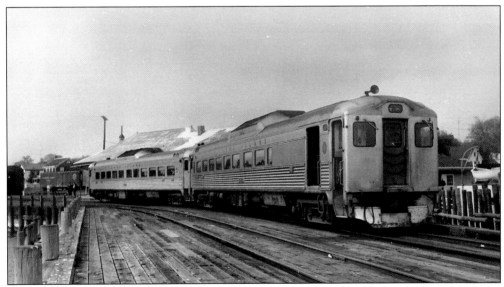

Budd RDC2 and RDC1 (Nos. 3121 and 3101, respectively) are coupled together in front of the Greenport depot, with RDC2 sitting on the wooden rail dock. RDC2 bears modernization No. 1 in the circle next to the baggage door, and RDC1 was assigned No. 49. This view, looking west, was taken in 1956. In the left background, a freight car can be seen on the team track. (Photograph by W. J. Edwards.)

Another early style of diesel used on the LIRR was Baldwin model DS4-4-1000 No. 450, built in April 1948. In this photograph, taken from the signal mast across from the yard limit sign, No. 450 and its westbound train leave Oyster Bay in 1950. The engineer appears to be hollering at the photographer to get down for his own safety. This unit was sold in 1964 and scrapped. (Photograph by J. P. Sommer.)

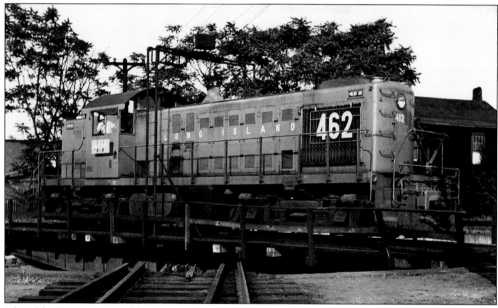

The old LIRR engineers liked to run their units long-nose forward, likely a carryover from steam days, so it was not unusual to see an occurrence like this in the early 1950s. Alco model RS1 No. 462, in the Tichy color scheme with a shadowed map under the cab window and battleship-style numbers on the side louvers, is spun on the Oyster Bay turntable in 1950. (Photograph by J. P. Sommer.)

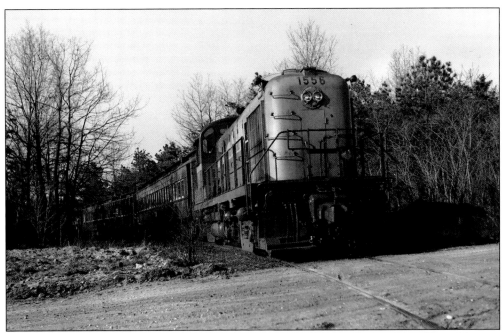

Pulling a railfan extra in May 1968, Alco model RS3 No. 1556 is on the westbound leg of the wye at Upton Junction after having run the train up the former Camp Upton branch on the grounds of the Brookhaven National Laboratory. The RS3 is crossing one of the dirt roads at the old junction and is heading toward the main line for its return trip. (Photograph by W. J. Edwards.)

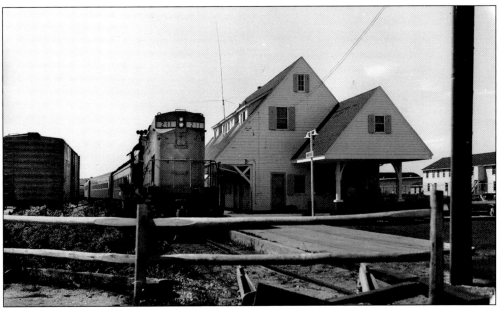

Alco C420 No. 211 and its train are literally at the end of the line in this 1968 westward view from the end of the track at Montauk, the easternmost terminus of the line. The lead car is an old heavyweight parlor. A lone boxcar sits on the freight siding, and the old navy buildings on the site of the original LIRR terminal are visible at the right. (Photograph by Bob Lorenz.)

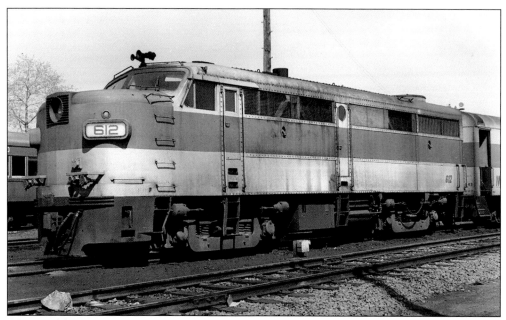

Alco model FA-1m No. 612 was one of a number of units acquired for use in push-pull service. As the control cab coupled on the east end of the train, a powered C420 would be coupled on the west end. The train would be "pushed" east and "pulled" west. Engines did not need to be turned or run around the train. This photograph was taken at Oyster Bay in April 1974. (David Keller Archive.)

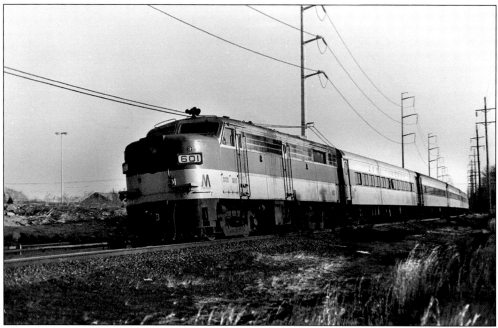

Also used in push-pull service were the Alco model FA-2m control cabs. Here, No. 601 leads train No. 4651, running at speed through Syosset in April 1972. This unit was built in June 1956 and was owned by the Louisville and Nashville Railroad. The FA-2m units were acquired in 1971, while the FA-1m units were acquired a year later. (David Keller Archive.)

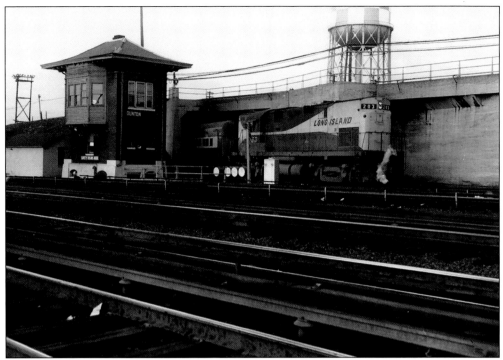

Backing its train into the concrete portal under the Montauk branch embankment, Alco C420 No. 213 passes Dunton tower as it accesses the Richmond Hill Storage Yard in this January 1966 northwestward view. The message "Safety Begins Here" is stenciled in large letters under the lower front window of the interlocking tower. (David Keller Archive.)

This September 1950 view looks northwest toward the station area in Babylon. Seen from left to right are the old depot, pedestrian overpass, express house, Alco RS1 No. 465 with its train, an MU combine car with an electric train, the semaphore arm block signals, and the old diamond crossing sign at the Depot Place grade crossing. (George E. Votava Collection.)

This view looks north toward the tall, steel girder trestle over Old Town Road east of Setauket in January 1972. Alco FA-2m control cab No. 602 performs push-pull service as it is pulled westbound amidst the barren trees. A June 1956 product of Alco, it too ran on the Louisville and Nashville and was acquired by the LIRR in June 1971, where it was converted to a control cab. (Photograph by David Keller.)

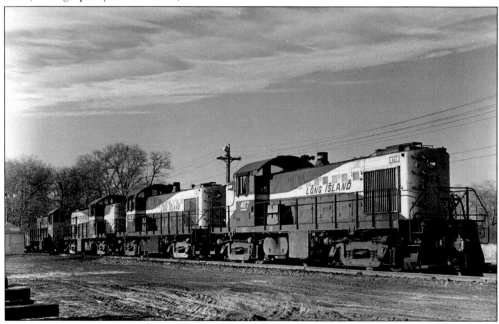

Having completed a heavy haul of stone for track work along the main line, these Alco units lay up at the wye at Ronkonkoma in 1969. From front to rear, we see RS1 models numbered 467, 468, and 469, as well as S2 model No. 456. At the far left is the tool shanty that was once located south of the main and served as KO block station. (Photograph by Jules P. Krzenski.)

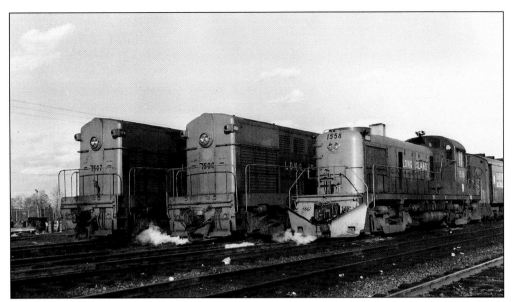

Neatly spaced and laying up facing westward awaiting departure time are Fairbanks-Morse H16-44 models numbered 1507 and 1506 and Alco model RS3 No. 1558. This photograph was taken at Ronkonkoma yard in January 1964, and the FM units are about to be retired and replaced with new Alco C420 models. Discolored spots under the headlights show where their builder's plates have already been removed. (Photograph by George E. Votava.)

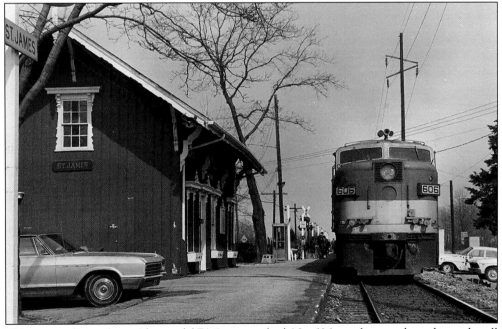

This eastward view shows Alco model FA-2m control cab No. 606 traveling westbound in push-pull service as it approaches the antique 1873 depot at St. James in March 1973. An Alco C420 pushes the train on the east end, while the engineer operates from this cab. Originally on the east end of the trains, the control cabs were later placed on the west end. (Photograph by David Keller.)

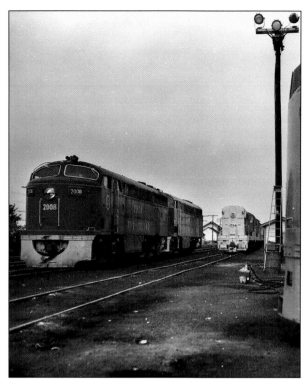

The West Yard at Port Jefferson, seen here in 1957, was located west of the depot and the Route 112 crossing and served as a lay-up yard for both locomotives and trains. Looking east toward the express house, which was the original depot building, this view reveals Fairbanks-Morse models CPA20-5 No. 2008 and CPA24-5 No. 2401 at the left and FM model H16-44 No. 1504 at the right. (Photograph by Jules P. Krzenski.)

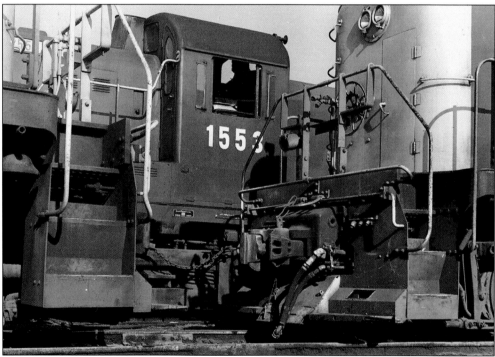

The cab of Alco model RS3 No. 1553 is framed between the nose of RS3 No. 1556 and the steps of RS3 No. 1558 as they all lay up in the yard at Ronkonkoma on a sunny day in 1957. (Photograph by Jules P. Krzenski.)

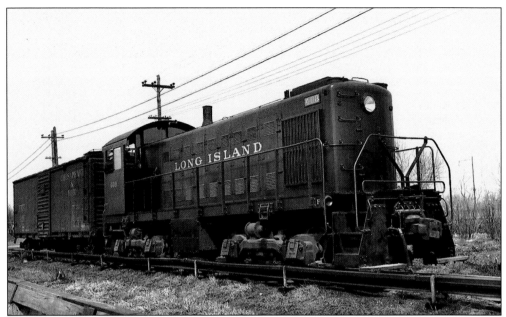

Sitting on the lay-up track north of the Country Life Press station in Garden City are Alco model S1 No. 408 and a sole Chesapeake and Ohio boxcar on May 20, 1948. The engineer relaxes and leans his arm and back against the cab window while awaiting permission to leave and spot this car somewhere along the Hempstead branch. (George E. Votava Collection.)

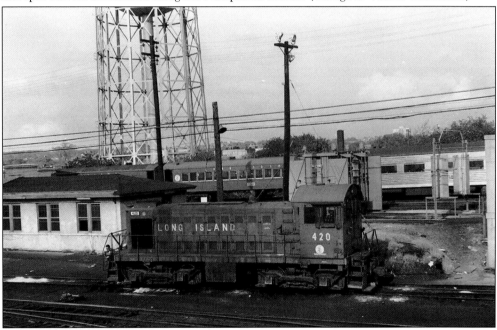

In this August 1970 northward view, Alco model S1 No. 420 sits near the trainmen's building in the Richmond Hill Storage Yard. From the embankment, part of the building is visible at the left, and the car washing machine is visible behind the locomotive. In the background are some Ping-Pong cars and one of the former New York Central cars billed as Silver Streak. (David Keller Archive.)

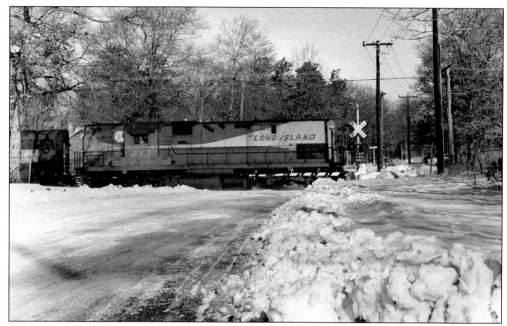

Winter has dumped a nice load of snow on Long Island, making for a picturesque action scene as Alco C420 No. 213 pulls Greenport train No. 204 eastbound at speed over the Blue Point Road crossing east of Holtsville in 1969. In this northward view, the crossing has only recently been converted to automatic gates and lights. (Photograph by David Keller.)

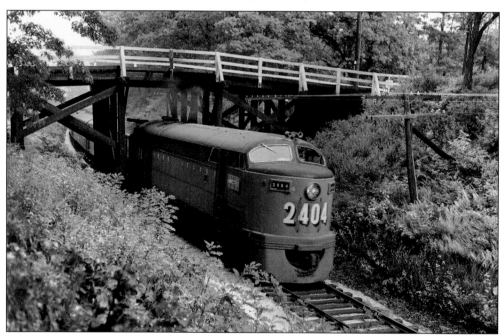

Fairbanks-Morse model CPA24-5 has just left Port Jefferson and is headed westbound as it passes under the old wooden trestle of Sheep Pasture Road in 1957. Built in September 1951, it was one of four 2,400-horsepower units in use on the LIRR and was retired between February and April 1964. (Photograph by Jules P. Krzenski.)

Four

THE FREIGHT BUSINESS

Since their inception over 150 years ago, railroads have existed to move people and goods. The mainstays of most railroads are their freight operations, unlike the Long Island Rail Road, which does a massive daily commuter business.

Unseen by most, however, the LIRR had a viable freight operation serving communities and industries from Long Island City eastward to the far-reaching end points of Long Island. Daily "extras" were assigned to pick up, spot (deliver), and move freight on and off the island. Every town and village served by the LIRR usually had a local coal dealer, lumber supply, and team track. Customers without rail sidings would send a team of horses and a wagon to retrieve shipments. Lumber, coal, building supplies, cement, and other raw materials were shipped in to feed the building booms and eastward expansion. Shellfish, potatoes, sand, fruits and vegetables, and finished goods were shipped out. The average LIRR freight was 25 to 35 cars in length, but occasional 50-car coal drags or 100-car potato trains heading west for New York markets were not uncommon.

Bringing up the rear was the ubiquitous caboose, or "hack," as it was termed. The caboose was the conductor's office, a place of shelter from the elements, and a useful vantage point to watch the freight cars for any potential trouble such as "hot boxes" in the wheels or possible derailments.

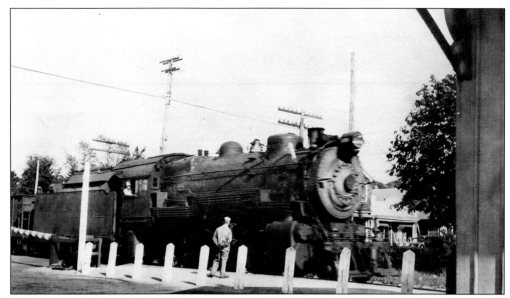

In this view, looking southeast from the rear of the Central Islip depot, Consolidation class H10s (2-8-0) No. 103 switches an afternoon freight westward over the Carleton Avenue crossing during the summer of 1933. The brakeman stands on the station platform as the engine passes, displaying white flags on the sides of its smoke box. Visible at the left are the unique pole gates that guarded this crossing until 1958. (Photograph by George G. Ayling.)

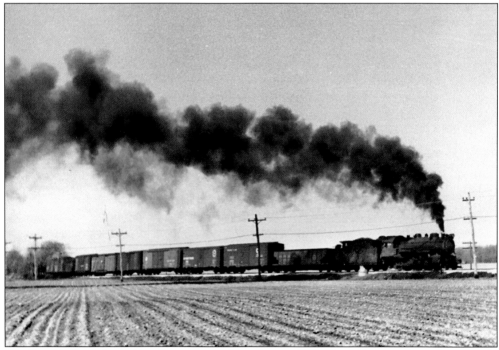

Chuffing black smoke and hauling a string of freight cars, H10s No. 112 passes through a recently plowed field east of Cold Spring Harbor in 1950. This area was still very rural at the time and, like the eastern portion of the main line, consisted of many acres of farmland. (Photograph by Frank Zahn.)

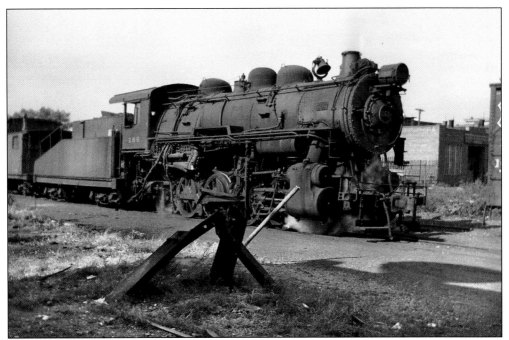

C51sa No. 269 pulls a class N52A wooden cupola-topped caboose near Maspeth around 1946. The sloped-back tender with handrail has a full load of coal, and the locomotive's bell is ringing. In the foreground are the remains of a beaten-up end-of-track steel bumper. (Photograph by Rolf H. Schneider.)

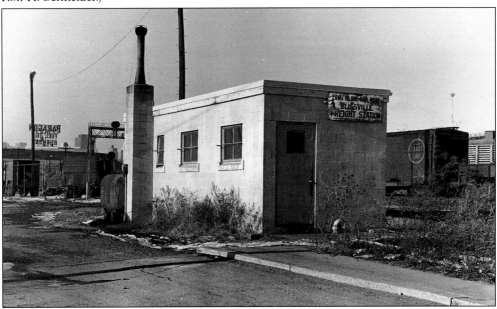

Important features in the freight business were the houses built at most station locations to store and record the freight carried. The size of these manned offices depended on the amount of freight handled there. This little concrete block structure housed the Blissville freight station in Long Island City in December 1970. It had been built in the late 1950s as the freight business was dwindling. (Photograph by David Keller.)

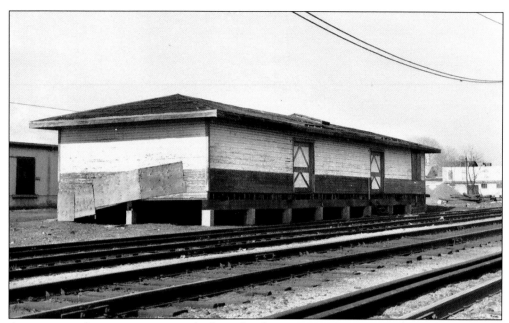

A contrast to the previous scene is the huge freight station at Huntington, shown here in 1969. Located north of the tracks and west of New York Avenue, the structure would not last. The long, wooden trackside platform has since been removed, along with the ramp at the near end of the structure. (Photograph by David Keller.)

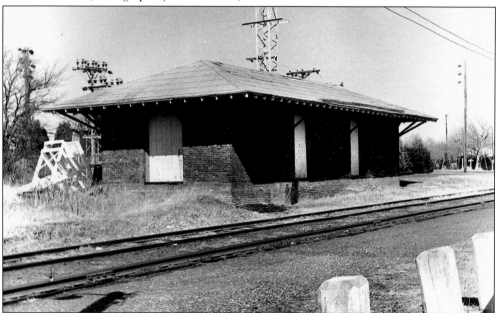

The old freight house at Amagansett is a medium-sized but substantial structure. Built in 1895, the brick building is shown without its wooden platform in this April 1970 view looking northeast. In 1895, when the Montauk branch was extended from Bridgehampton to Montauk, Amagansett became a major terminal with a roundhouse, turntable, water and coaling facilities, and a boardinghouse for train crews. Very few trains made the full trip east. (Photograph by David Keller.)

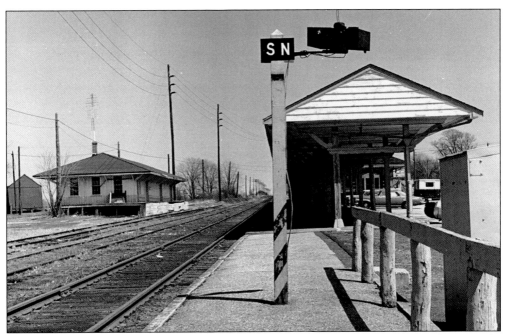

This April 1970 view, looking east at Southampton, reveals the old wooden freight house at the left. The wooden platform is still intact but is beginning to decay. The station, with long covered platforms, is at the right, and in the foreground is the SN block limit station signal, consisting of an electrified old kerosene-type lamp. Express houses were once located at the ends of these covered platforms. (Photograph by David Keller.)

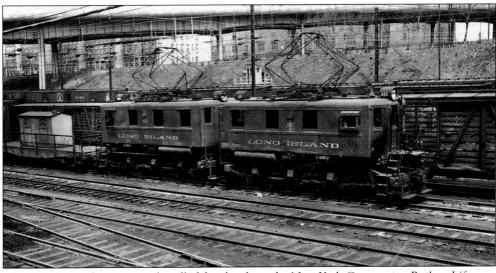

Class B3 electric locomotives handled freight along the New York Connecting Railroad (former Bay Ridge branch). Nos. 337 and 325, with the aid of an idler, or "reach" car, load or offload one of the car floats in Bay Ridge yard in April 1946. The idler acted as a spacer car and kept the locomotive's weight off the float. (H. Forsythe Collection, David Keller Archive.)

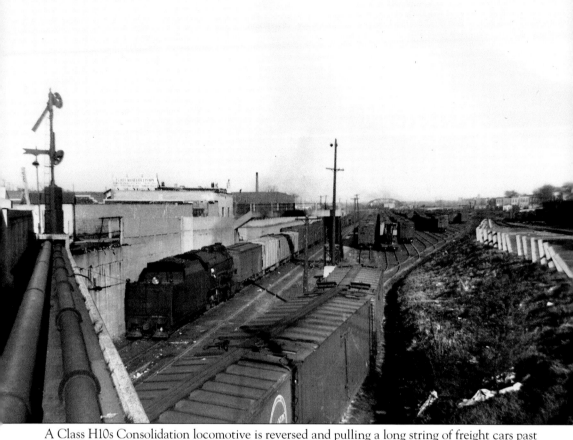

A Class H10s Consolidation locomotive is reversed and pulling a long string of freight cars past the Fresh Pond station in 1944. Looking southeast from the Metropolitan Avenue overpass, this view shows the semaphore home signal mounted on the bridge and the c. 1915 pedestrian crossover to access the crushed-cinder station platform. In the center background is the New York Connecting Railroad bridge, whose base is adjacent to Pond tower. The West Yard can be seen in the right background. (Photograph by W. J. Edwards.)

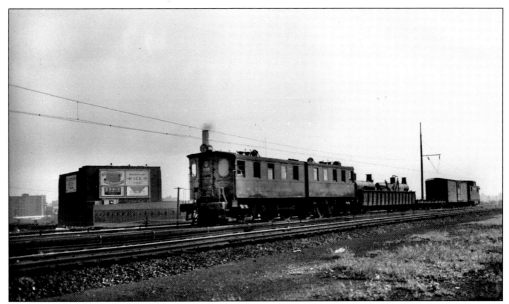

Freight sidings in electrified territory were equipped with a third rail so they could be serviced by either electric or steam locomotives. DD1 class electric locomotive No. 338 leads a four-car freight train westbound through Sunnyside, Long Island City, in August 1937. The Knickerbocker Ice Company is visible at the left. The DD1 class locomotive was frequently used in both passenger and freight service. (Photograph by George E. Votava.)

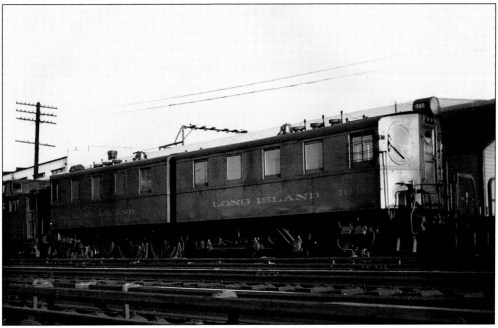

Electric service reached Babylon in 1925, and the town remained the easternmost point of electrification for many years. In this view from March 1936, DD1 No. 349 and N52A class caboose No. 18 lay up at the Babylon freight house. They have either just finished a job switching freight along the electrified Montauk (Babylon) branch or are awaiting their crew to head out for another long day. (George E. Votava Collection.)

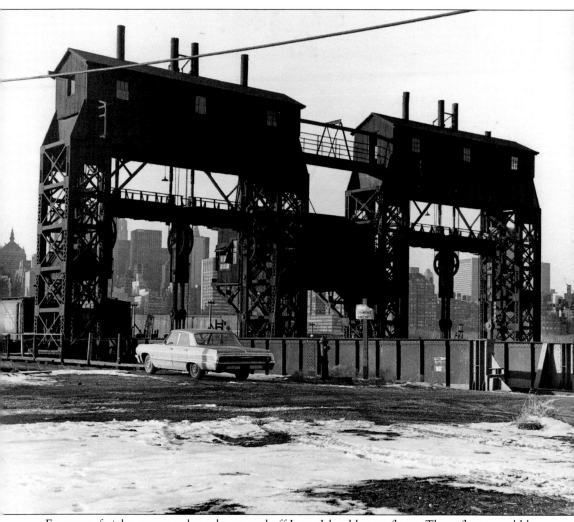

For years, freight cars were brought on and off Long Island by car floats. These floats would be pulled by tugboat and maneuvered into position underneath float docks. The docks would raise or lower the connecting track platform to match the car float level due to the differing heights resulting from the tides. They would be loaded or unloaded by means of a switcher locomotive and an idler, or reach car, which was designed to keep the weight of the engine off the barge, yet provide the engine crew with sufficient visibility. This view of one pair of the Long Island City float docks was photographed in January 1971, looking northwest. The New York City skyline appears in the background across the East River. (Photograph by David Keller.)

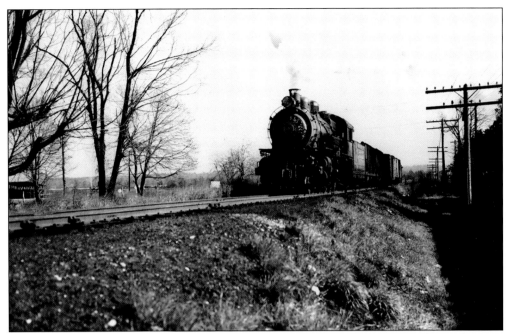

Consolidation class H6sb No. 307:2 pulls an early-morning freight westbound out of Oyster Bay on this winter's day in 1940. The morning sun backlights the short train as it approaches the switch to Jakobsen Shipyard, located beyond the photograph to the left. (Photograph by T. Sommer.)

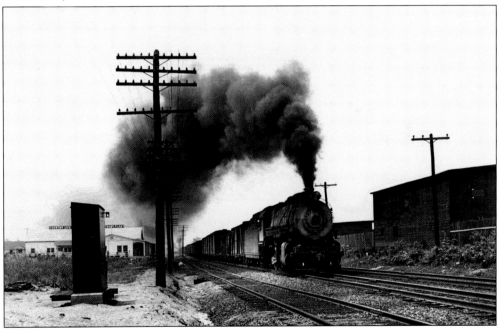

Under a plume of smoke, H10s No. 101 leads a string of freight cars eastbound through Westbury in June 1947. The train appears to stretch as far as the eye can see as it passes the Country Life Press Westbury plant. In the distance, the old freight house at Westbury station is visible. (Photograph by George E. Votava.)

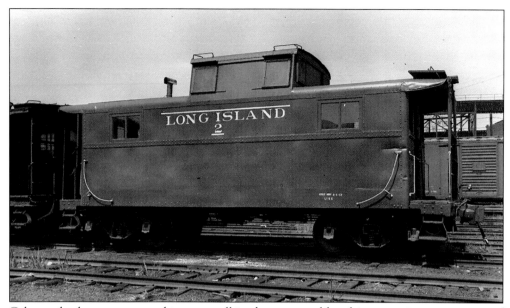

Caboose, hack, crummy, or cabin car—call it whatever you like, this was an important piece of equipment to freight crews. It was the freight conductor's office and crew bunkroom. It carried the equipment necessary to freight service and included toilet facilities, a potbellied stove, and a cupola to observe the train ahead. Class N5b steel caboose No. 2 is shown here at Long Island City in August 1953. (George E. Votava Collection.)

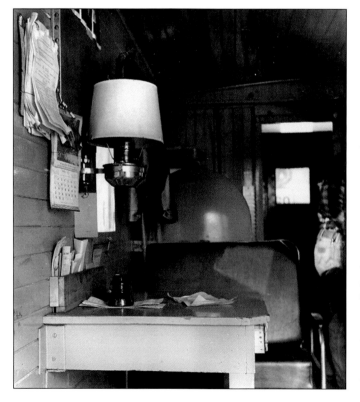

The close quarters inside a caboose are evidenced in this view of the freight conductor's small desk, with a shaded kerosene lamp attached to the wall and a green-glass insulator acting as a paperweight. Caboose C92 was one of several former Illinois Central hacks with cupola top acquired by the LIRR in January 1972. This photograph was taken at Patchogue in October of the same year. (Photograph by David Keller.)

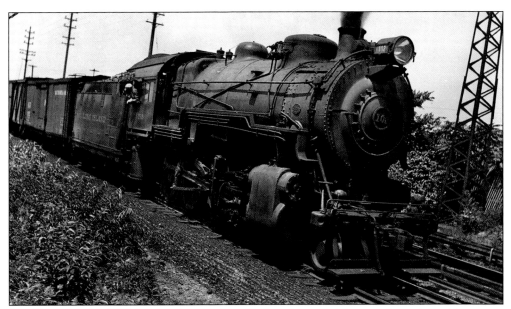

In addition to the DD1 locomotives in electrified territory, freight was also switched by steam. H10s No. 102 pulls a string of freight cars past the third rail as it trundles through Lynbrook in July 1937. The engineer leans out his cab window to check on the condition of the train behind him. (George E. Votava Collection.)

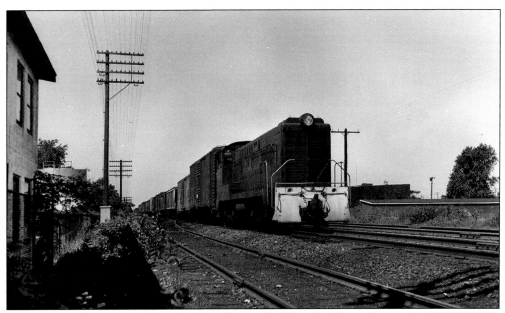

Steam was on the wane in July 1952, when this new Baldwin diesel was photographed. Model DS4-4-1000 No. 450 leads a long string of cars through Hicksville. A product of the Baldwin Locomotive Works in April 1948, this 1,000-horsepower unit was placed in both freight and passenger service. It was retired and sold for scrap in February 1964. (Photograph by George E. Votava.)

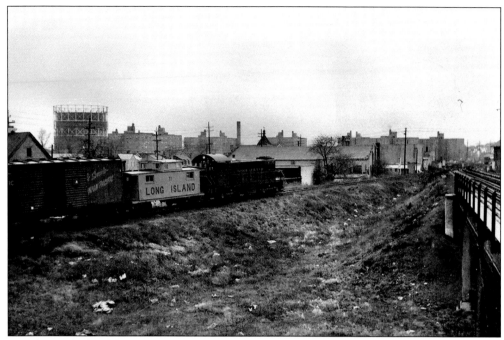

Another early diesel locomotive used toward the end of the steam era was Alco model S1. Here, No. 416 switches freight cars near Woodside around 1950. Wooden class N52A caboose No. 11 is positioned behind the locomotive to allow the cars to be spotted at different sidings without the hack being cut off each time. (David Keller Archive.)

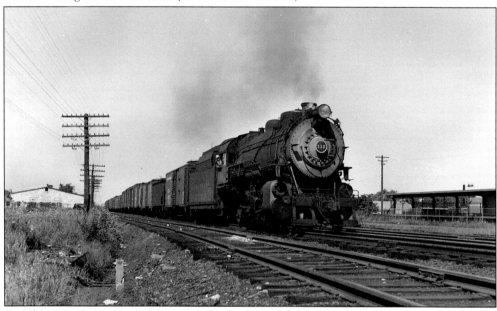

By July 1952, the H10s class locomotives had become the only steam power in LIRR freight service. The last of the leased Pennsylvania Railroad locomotives had all been returned, and the G5s class locomotives were handling passenger service. Here, H10s No. 117 pulls a 21-car freight train through Hicksville bound for Port Jefferson. Within three years, diesels would secure a complete takeover. (Photograph by George E. Votava.)

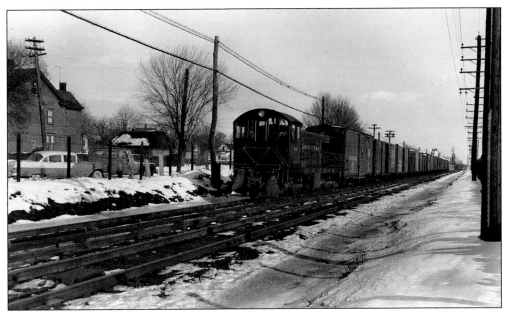

Steam is gone and diesels are here to stay in this snowy view from January 1958. Alco model S2 No. 452 runs westbound and cab-forward at New Hyde Park with a 16-car freight train in tow. Though it provided increased visibility, running in reverse was difficult for the former steam men to handle; they rarely ran their engines in this manner. (Photograph by George E. Votava.)

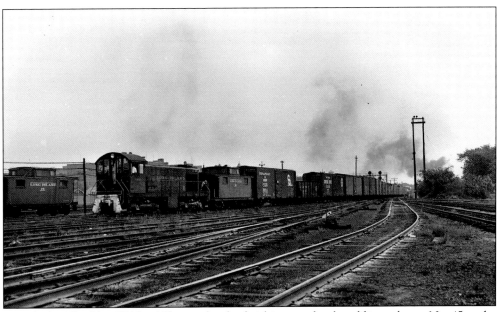

On July 5, 1954, Alco S2 No. 460 provides the finishing touches by adding caboose No. 45 to the rear of a 59-car freight it has prepared at Holban Yard in Hollis to be hauled eastbound by H10s steam locomotive No. 111. The H10s's smoke is visible behind the trees in the right background. Caboose No. 18 lays up at the left. (Photograph by George E. Votava.)

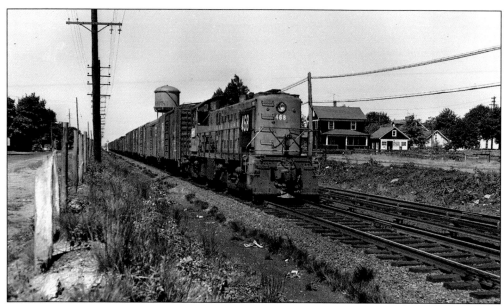

Alco RS1 No. 468, in the Tichy color scheme with battleship numbers on its side louvers, pulls a freight train through New Hyde Park in July 1953. The diesel locomotives are beginning to fill in regularly for the steam locomotives, as the model RS1 was used in both freight and passenger service. Built by Alco/GE in April 1950, it would serve the LIRR for 27 years. (Photograph by George E. Votava.)

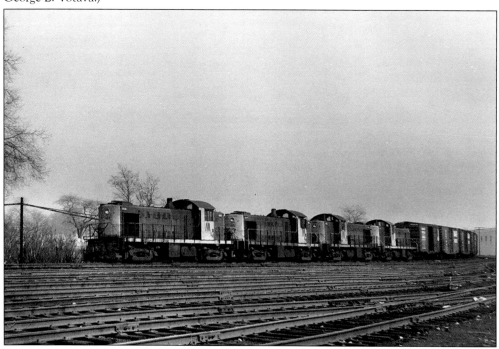

This is a four-unit lash-up of Alco RS1 models, with Nos. 469, 465, 468, and 467 pulling a freight train westbound on the Montauk branch west of Glendale in March 1971. All units bear the MTA color scheme of blue and yellow as they pass the empty East Yard toward Pond tower and Fresh Pond. (David Keller Archive.)

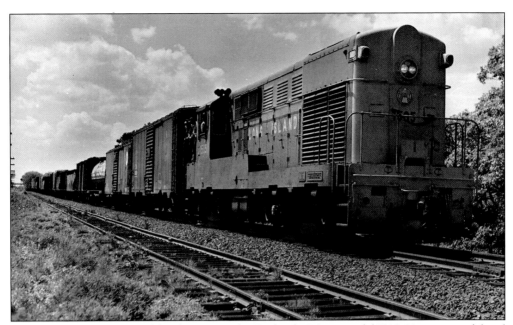

Used for both passenger and freight service, the Fairbanks-Morse model H16-44 was powerful and versatile. Here, No. 1505 uses its 1,600 horsepower to pull an early-afternoon freight eastbound from Ronkonkoma in 1957. Built in October 1951, this unit would be retired between 1963 and 1964 and sold after being replaced by the arrival of the Alco C420 Century models. (Photograph by Jules P. Krzenski.)

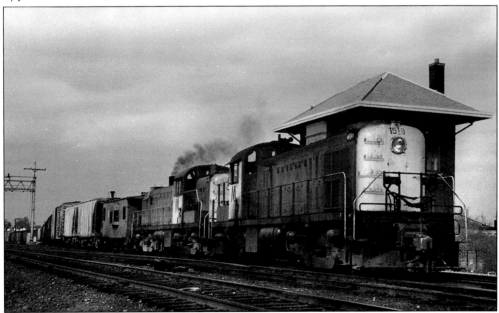

Oftentimes running as a pair, the LIRR's only Alco RS2 models, numbered 1519 and 1520, along with a caboose and freight train, pass Fremont tower at Fresh Pond Junction in April 1971. Viewed from the New York Connecting Railroad tracks, the train is snaked along the connection to the Montauk branch. These units were acquired from the Delaware and Hudson Railway in August 1962. (David Keller Archive.)

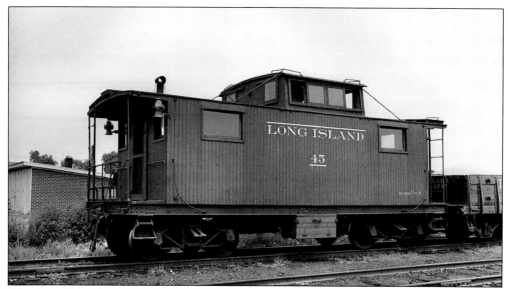

Wooden N52A caboose No. 45 is shown here at Hicksville, coupled to LIRR gondola No. 2715 at the rear of a work train in July 1937. Built in 1916, this caboose was the standard model in use on the LIRR for many years. With a wooden body, cupola top, and steel frame, it put in lots of trip miles and was home to many crewmen in its lifetime. (Photograph by George E. Votava.)

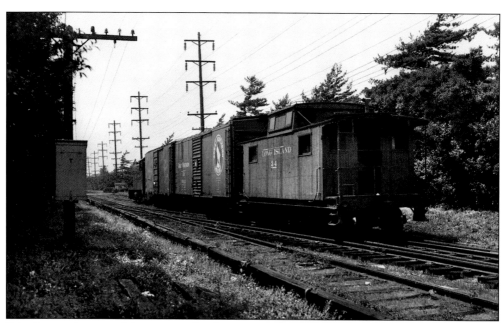

Bringing up the rear of this two-car freight train is wooden caboose No. 34. It ambles along the Central branch extension at Washington Street, Garden City, in July 1953. On the head end is Baldwin model DS4-4-1000 No. 450. The short train is passing the T box at left, which houses the LIRR's old-style magneto crank-handled phone for crew use. (Photograph by George E. Votava.)

Five

PASSENGER SERVICE

The heart of all LIRR operations is passenger service, primarily in the form of daily commuter runs. Engines such as the G5s class (4-6-0) were designed for fast acceleration and power to pull the steel coaches the short distances from station to station. Later on, diesels were assigned this duty. There were the venerable "Ping-Pong" cars, so called for the bouncy ride they provided when pulled by steam and diesel locomotives. In use on unprofitable branches in the 1920s and 1930s were self-propelled railcars called doodlebugs, as well as a more up-to-date version: Budd Rail Diesel Cars. The LIRR also had electric multiple-unit commuter operations with the distinctive owl-eye end windows, followed in the late 1960s and early 1970s by the arrival of the M1 electric cars.

Parlor cars were fondly remembered by many. Going back to 1926, Pullman cars from the Pennsylvania Railroad's equipment pool were frequently used on trains such as the *Sunrise Special*. Then, starting in October 1958, the LIRR acquired used heavyweight cars of its own. Utilized during the summers and on name trains such as the *Cannonball* and the *East Ender*, these cars became the Blue Ribbon Fleet, offering extra fare accommodation. Also provided was private club car service on certain branches. From 1968 to 1970, lightweight, used sleeping cars, sleeper-lounge cars, buffet lounge cars, and tavern-lounge-observation cars were purchased to replace the aging heavyweights in parlor car service.

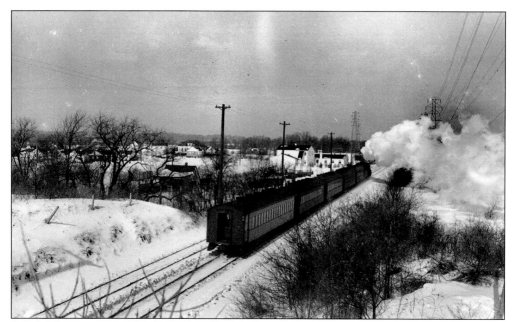

Rural Albertson is viewed from a small rise while G5s No. 33 pulls train No. 4514 eastbound through the snow-covered town in February 1948. The photographer has captured the train from the rear as it heads toward Oyster Bay. The steam from the locomotive's stack is crisp in the frigid air. (George E. Votava Collection.)

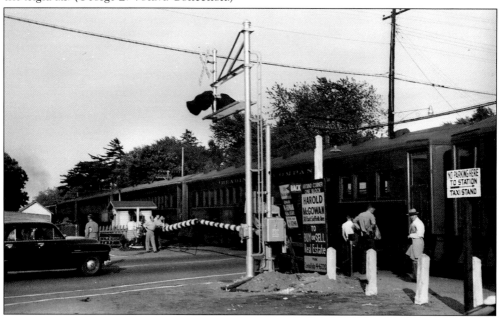

Reading Company coaches perform LIRR service at Central Islip around 1958. Looking southeast, this view shows the eastbound train crossing Carleton Avenue. Visible are the old manual pole gates and manned wooden crossing shanty—both about to be replaced by the newly installed automatic crossing lights still covered on their mast. The pole gates were constructed from telephone poles and lowered by ropes. They were unique to Central Islip. (Photograph by W. J. Edwards.)

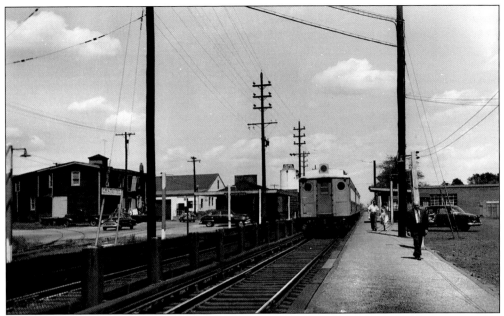

A three-car MU train bearing the Tichy color scheme has just made a noonday stop at New Hyde Park station around 1954. The train will continue eastbound to Mineola. The depot was opened in 1947, replacing the old wooden structure across the tracks that dated from 1870. The siding curving to the left accesses G. H. Stattel's seed and feed warehouse, while the team track continues straight. (Photograph by W. J. Edwards.)

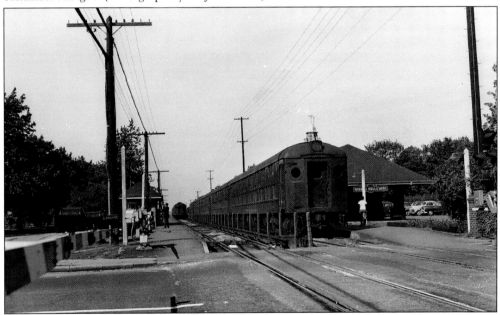

On a September day in 1948, MU double-decker No. 1346 brings up the rear of a westbound five-car double-decker train at Nassau Boulevard station in Garden City. The old depot sports the cast-iron Pennsylvania Railroad keystone-style station sign. The gates remain down as an MU train approaches the station area eastbound on the adjacent track. (Photograph by George E. Votava.)

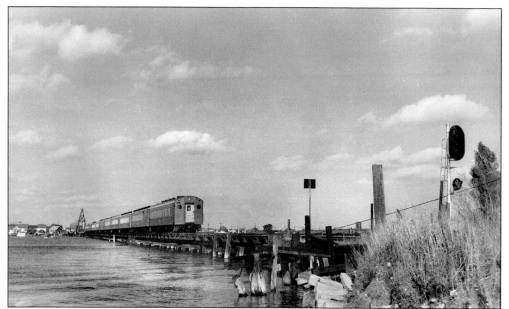

An MU train crosses the wooden-pile trestle over Reynold's Channel at Long Beach on a summer day around 1960. It is unusual to see a combine car as the second car of the consist. The train has just passed Lead interlocking cabin and crossed over the swing bridge, whose A-frame tower is visible behind the train. At the right is a block signal for oncoming trains. (Photograph by W. J. Edwards.)

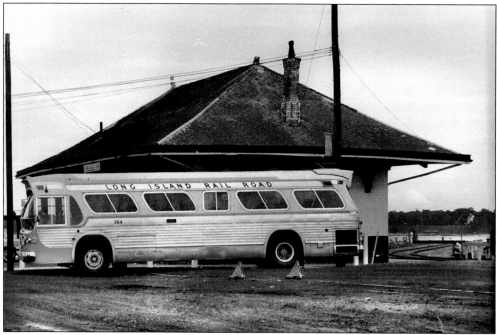

An alternative to taking the train was offered by the LIRR in the form of Road 'n' Rail subcontracted bus service. These buses picked up the slack caused by cutbacks in train service on the eastern end of the island in the early 1960s. Here, bus No. 364 appears alongside the depot at Greenport in 1962. The rail dock is visible to the right. (Photograph by J. P. Sommer.)

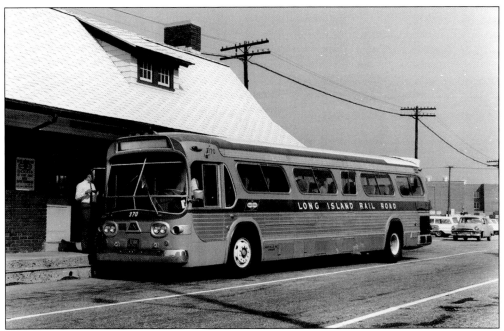

In another scene of Road 'n' Rail service, bus No. 370 is just arriving at the rear of the Riverhead station during the summer of 1968. The few passengers who will be boarding are in the depot waiting room. Separate fares were required for this service; train tickets and employee passes were not honored on the bus. (Photograph by David Keller.)

This view of Babylon, looking northwest toward the elevated station and tracks, shows Road 'n' Rail bus No. 371 awaiting a train connection outside the ticket office in 1969. The two main bus routes were Greenport to Huntington and Montauk to Amityville. (Photograph by Jules P. Krzenski.)

The year 1950 was a hard one for the Long Island Rail Road. Besides financial troubles, a deadly accident at Rockville Center in February was followed by a horrible collision at Richmond Hill (actually 1,960 feet east of the Kew Gardens station) in November. One result of the latter was the installation of a clearly visible rear marker lamp. This closeup was taken at Oyster Bay in 1952. (Photograph by J. P. Sommer.)

A factor in the February 1950 disaster at Rockville Center was the use of the gauntlet track, which consisted of two tracks overlapping to utilize available space. Opposing trains wound up simultaneously traveling on their portions of this track and collided head-on. In this scene, prior to the collision, a double-decker train traverses the gauntlet track. The grade elimination is visible at the left. (David Keller Archive.)

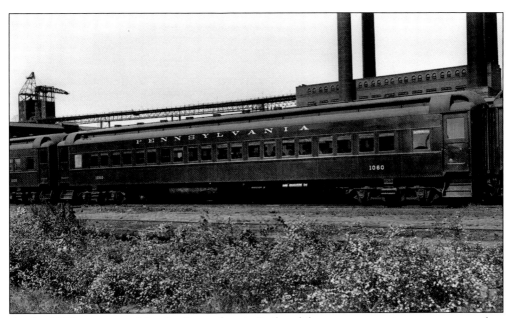

As the LIRR was owned by the Pennsylvania Railroad for many years, it was not unusual to see PRR equipment, such as parlor cars and baggage cars, running on the LIRR tracks. Here, regular passenger car No. 1060 is on a train of PRR coaches at the passenger terminal at Long Island City. Also visible in this October 1936 northward view is the PRR electric power plant. (Photograph by William Lichtenstern.)

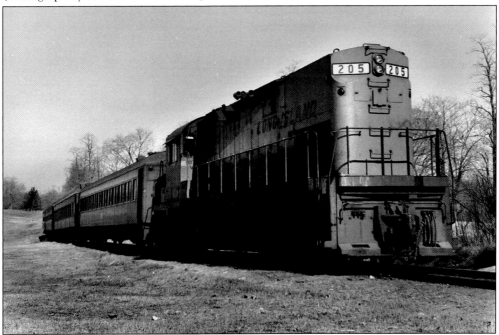

The LIRR provided regularly scheduled passenger trips to the state mental hospitals. Run on Sundays, the trains would drop off visitors and lay up either on the hospital grounds or in a terminal yard. Alco C420 No. 205 and its train rest just beyond the Kings Park State Hospital station platform in this 1969 view. (Photograph by David Keller.)

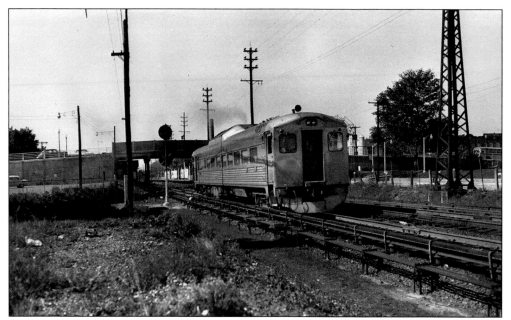

The Budd car was a popular sight on the east end of the island for many years. RDC2 No. 3121, with a baggage compartment and *East Ender* logo on its end doors, would regularly make trips east. Designated Riverhead train No. 4286, it is headed eastbound at Mineola in October 1955. Looking west from Nassau tower, this view reveals the freight-only spur to Garden City at left. (Photograph by George E. Votava.)

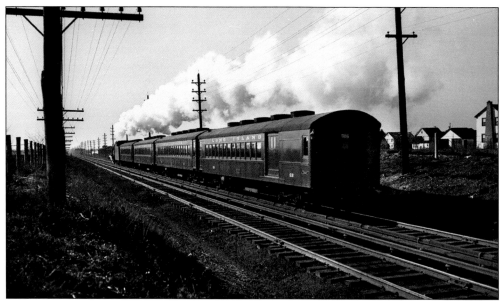

The late-afternoon sun glistens off the side of G5s and the four-car Oyster Bay train traveling westbound at Mineola in February 1937. The train has just departed the station and is heading toward Jamaica, with combine car No. 618 bringing up the rear. The steam is crisp in the cold air, which will soon become even chillier as the sun sets. (Photograph by William Lichtenstern.)

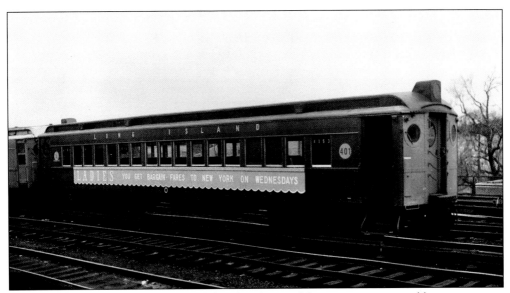

Before the days of shopping malls and the abundance of department stores and boutiques, most people did their serious shopping in Manhattan. The LIRR offered special "Ladies Day" rates on Wednesdays to encourage women to ride the LIRR for their shopping forays. MU car No. 4153 sports the "Ladies Day" banner at Jamaica in this 1962 view. (Photograph by W. J. Edwards.)

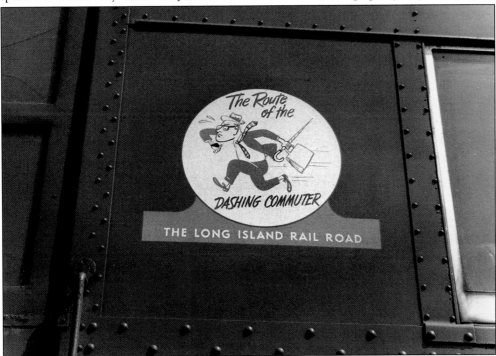

Beginning in 1958, the LIRR decided to create a new logo called "The Route of the Dashing Commuter," which stylized the typical LIRR commuter as "Dashing Dan." Dan, with fedora hat, eyeglasses, umbrella, and briefcase, runs to catch his train, sweating and desperately looking at his wristwatch. This logo was photographed in 1969, when it was displayed on the side of passenger car No. 7092. (Photograph by David Keller.)

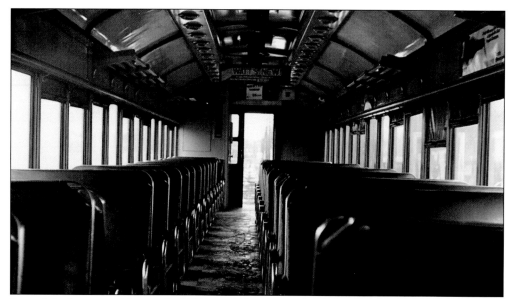

One of the bouncier rides on the LIRR could be obtained in a Ping-Pong car, so named because it "Ping-Ponged" the rider around. This interior view of car No. 7006, taken at Patchogue in December 1971, shows the ceiling fans and the three-two seating pattern. The handles on the corners of the seats allowed the crew to flip the backs when the train changed direction. (Photograph by David Keller.)

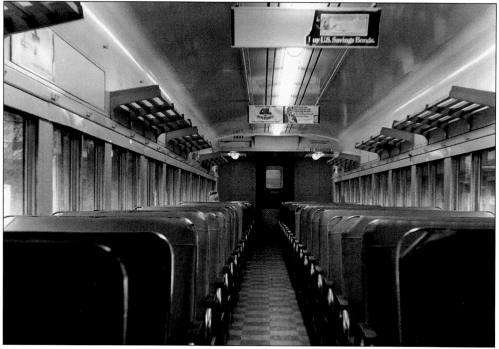

This interior shot is of a newer style car eventually converted to push-pull train service. Car No. 2833, a 1955 product of Pullman-Standard, is shown at Ronkonkoma in August 1972. These cars, much smoother rides than the Pings, were air-conditioned and well-heated. (Photograph by David Keller.)

One of the most famous trains on the LIRR was No. 18, the *Sunrise Special*. Departing from Pennsylvania Station, the all-parlor extra-fare train traveled along the main line to Manorville, branching off to Eastport, with Montauk its final destination. Here, G5s No. 21, the regularly assigned engine, pulls the *Sunrise Special*, complete with personalized tender herald, eastbound through Central Islip around 1927. (Photograph by George G. Ayling.)

Open-end observation car No. 100 of the Southern Pacific Railroad was an unusual visitor at Oyster Bay in 1939. The car sports a fabric awning and the words "official car" on its end door. G5s No. 22 appears at the water tower at left, and the brick freight house is visible to the right of the car. A string of freight cars is at far right. (Photograph by T. Sommer.)

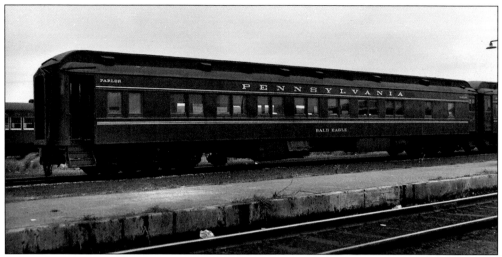

Before the LIRR acquired its own parlor car fleet, Pennsylvania Railroad parlors were used on trains to Montauk and Greenport. Laying up in the yard at Montauk in September 1951 is the PRR parlor car *Bald Eagle*. Built by Pullman in 1927, it had 28 chairs and one drawing room. (Photograph by George E. Votava.)

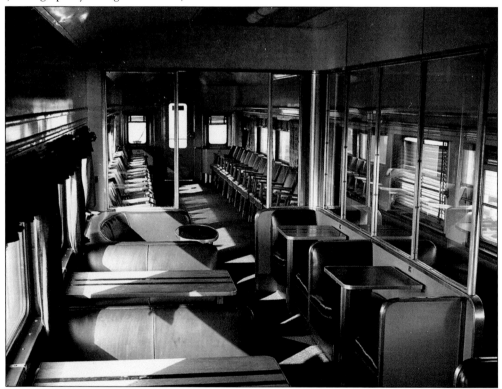

This interior view of the tavern lounge observation car *Asharoken*, assigned road number 2082 and photographed at Montauk in September 1974, looks toward the closed observation end, showing the tavern area separated from the lounge seating area by a half-wall topped with plexiglass. The small windows at the end of the car allowed a view of the tracks and right-of-way as one traveled. (Photograph by David Keller.)

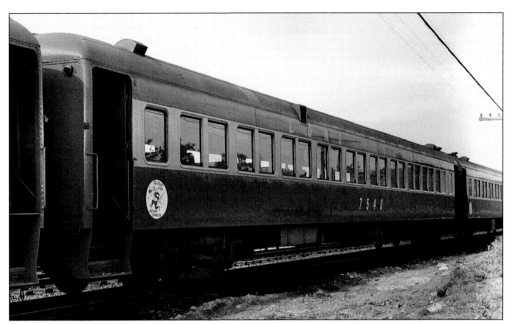

After the LIRR's Special Services Department started its parlor car service, the decision was made to also provide bar service to regular-fare passengers on the runs to the east end. Former Boston and Maine car No. 4598 was one of many converted to bar service. Seats were removed, an almost three-quarter-car-length bar was added, and the car was renumbered 7540. It was photographed at Ronkonkoma in 1969. (Photograph by David Keller.)

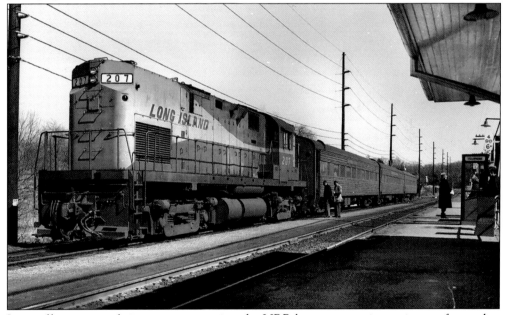

In an effort to upgrade its passenger service, the LIRR began to acquire equipment from other railroads in 1967. In this February 1968 view at Smithtown, Alco C420 No. 207, with three former New York Central stainless-steel cars, loads passengers as it prepares to head west. These shiny, fluted cars were advertised as Silver Streak service and attracted a lot of attention. (Photograph by Bob Lorenz.)

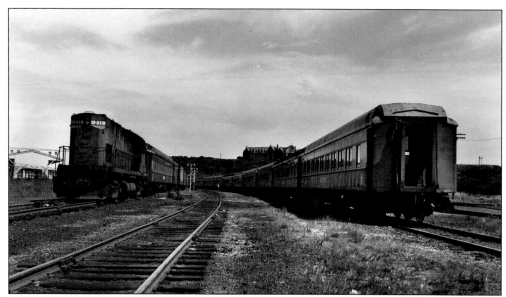

The majority of the LIRR's parlor car trains operated to the Hamptons, with the last stop at Montauk. In this eastward view toward Montauk Manor on the distant hillside, a full string of heavyweight parlor cars lays up at the right, while Alco C420 No. 211 prepares to depart westward with another heavyweight parlor car train in the summer of 1965. (Photograph by W. J. Edwards.)

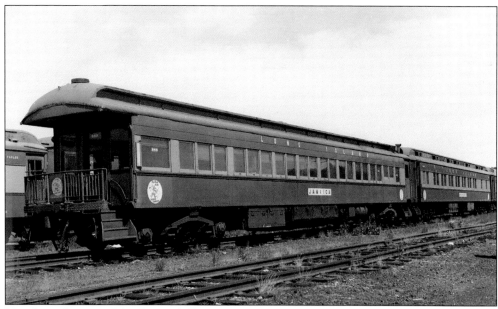

Usually at the rear of the *Cannonball*, open-end observation car No. 2000, named *Jamaica*, was also assigned to special inspection trains when top management rode the line. Here, it is on the end of a string of heavyweight parlors at Montauk in 1962. The small No. 240 in the window is the train (24) and car (0) assignment number. This number would vary by trip. (Photograph by W. J. Edwards.)

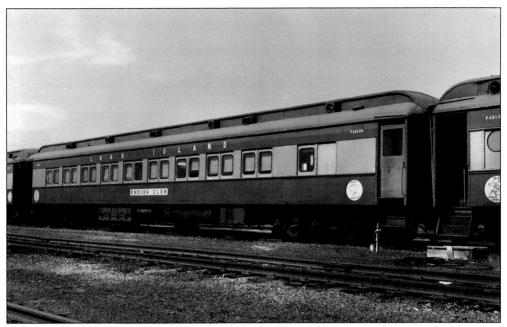

Heavyweight parlor car No. 2036, the *Oneida Club*, is with a string of heavyweight parlors laying up at Montauk in 1965. Built by Pullman in 1916 as class P74DL, it was originally Pennsylvania Railroad parlor No. 7052, named *Westdale*. Like the PRR parlor car *Bald Eagle*, the *Westdale* may have seen previous service on the LIRR in the Pennsylvania Railroad livery. (Photograph by W. J. Edwards.)

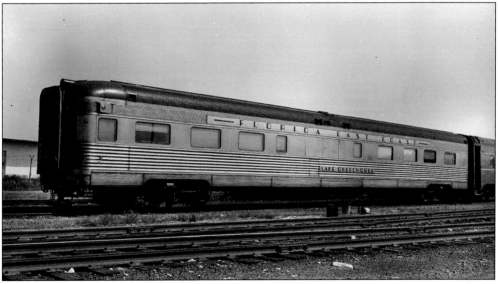

The later and more lightweight equipment acquisitions of the LIRR, starting in 1967 with the Silver Streak cars, included the Florida East Coast closed-end observation and tavern lounge car *Lake Okeechobee*, photographed at Montauk in June 1969. Built by Budd in 1947, the 64-seat car was acquired by the LIRR in October 1968, renumbered 2064, and renamed *Apaquogue*. (Photograph by William Lichtenstern.)

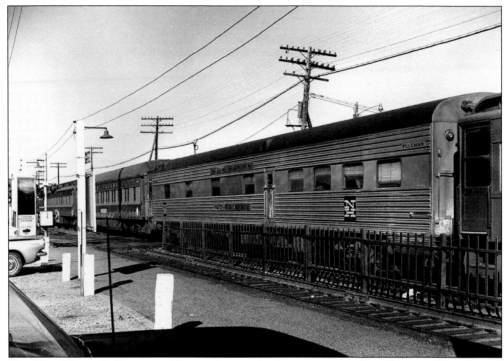

The New Haven Pullman car *Nutmeg State*, seen here on an eastbound Montauk parlor car train, passes through the station at Bay Shore on a summer's day in 1968. Ahead of it are two LIRR heavyweight parlor cars. The *Nutmeg State*, only a "guest," was not retained as a regular member of the new lightweight fleet. (Photograph by Jules P. Krzenski.)

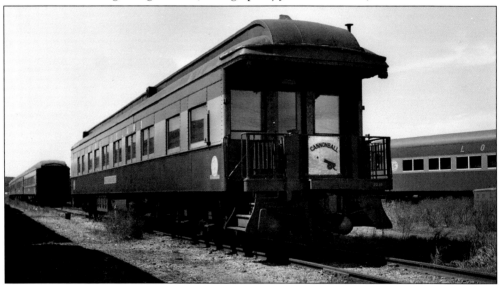

Replacing the *Jamaica* at the rear of the *Cannonball*, the open-end observation car No. 2038 *Setauket* lays up at Montauk in 1962 and displays the *Cannonball* drumhead. A 1912 product of American Car and Foundry, the class P73L car served on several roads before LIRR service and, in 1971, was renumbered 99:2 and renamed *Jamaica: 2* after the March 1968 retirement of the original *Jamaica*. (Photograph by W. J. Edwards.)

Six

THE MORRIS PARK SHOPS

The Long Island Rail Road's largest locomotive maintenance and repair facility was the Morris Park Locomotive Shops. Located just south of the Montauk branch, between the Morris Park and Dunton stations on the Atlantic branch, it was opened on November 1, 1889, and remained the major maintenance facility and heart of the railroad for many years.

The track layout changed occasionally over the years to accommodate functional requirements. However, most of the original 1889 buildings were still standing during the years 1925 through 1975. This facility consisted of the Maintenance of Equipment general offices, as well as an electric turntable, 23-stall brick roundhouse, wooden coaling and sanding tower (replaced in 1944 by a concrete structure), water tower, freestanding watering facilities for locomotives, bridge-borne watering facilities to fill multiple locomotives at the same time, bridge-borne smoke "washers" (to answer the complaints of local residents), oil storage house, locomotive repair and machine shops, blacksmith and tinsmith shops, mill and upholstery rooms, air brake rooms, battery house, Third Rail Department offices, transfer tables, passenger car shops, paint shops, truck shop and armature rooms, engine dispatcher's office, engine inspector's office, engine foreman's office, powerhouse, warehouse, functioning diner (in later years), and various switchman's shanties. There were also storage tracks for steam locomotives and a separate area for the storage of DD1 electric locomotives. Later, these tracks would continue to serve as storage for the diesel locomotive fleet.

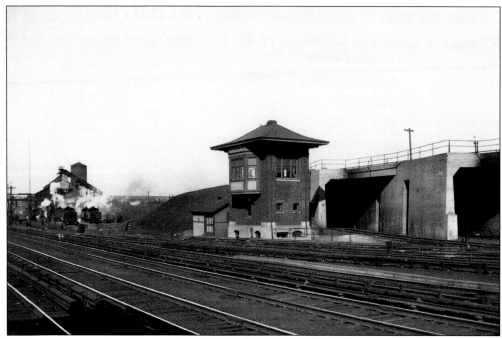

MP tower is seen from the Dunton station platform around 1925. Engineers picking up their locomotives and preparing to exit the Morris Park Shops, seen at far left, were required to stop for permission to leave or to reverse into the Richmond Hill Storage Yard, via the tunnels at right under the Montauk branch, to retrieve their passenger trains. (Photograph by James V. Osborne.)

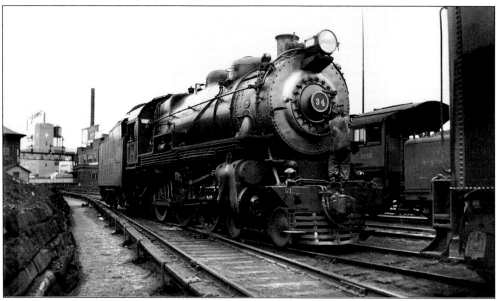

A shop worker mends the smoke box door of the G5s No. 34 while it lays up near the Montauk branch embankment in this August 1939 eastward scene. In the background, Dunton tower stands at left, and Dunton station is opposite. In the distance is the Sheffield Farms dairy plant. Dunton station would later be discontinued as a stop. (H. Forsythe Collection, David Keller Archive.)

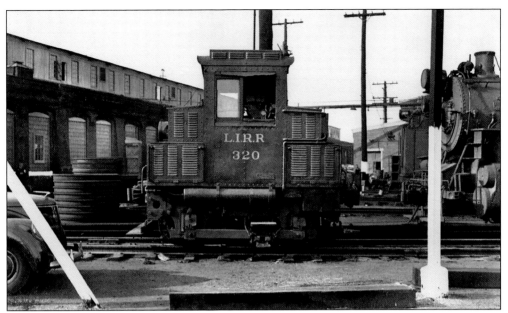

Class A1 electric shop switcher No. 320 sits on one of the turntable garden tracks (the uncovered tracks radiating from the turntable) in 1946. This little locomotive would pull equipment all over the yard, as well as in and out of buildings, via the transfer tables. The building at the left housed the locomotive repair and machine shops. (Photograph by W. J. Edwards.)

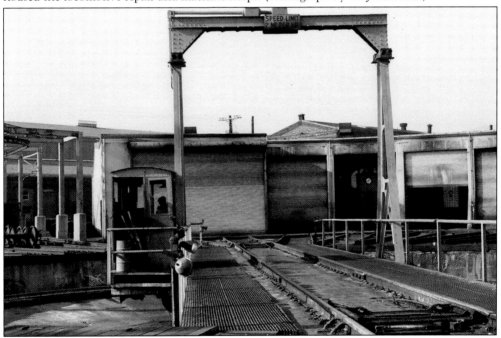

This 1966 view shows the electric-powered turntable used to access the various tracks leading from the turntable as well as the roundhouse, which can be seen in the back beyond the turntable pit. A gap was created by removing the center portion of the original 23-stall brick roundhouse, leaving two separated halves, the easternmost of which was demolished some years earlier. (Photograph by David Keller.)

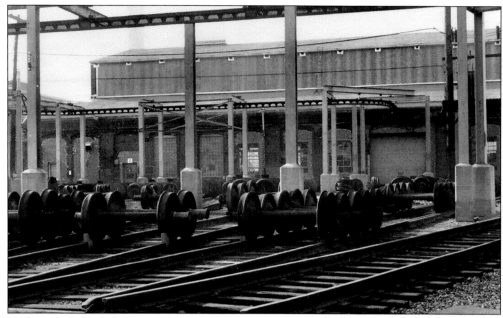

Looking west from the turntable in 1966, this view reveals the outside wheel-storage tracks in the foreground and the locomotive repair and machine shops in the background. The overhead door at right is one of two that accessed the interior wheel storage via rail. An overhead crane rail is also visible in front of the building. (Photograph by David Keller.)

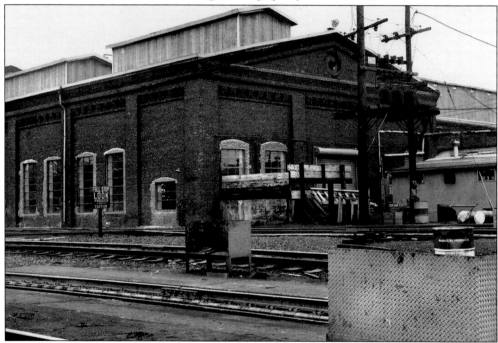

The building housing the blacksmith and tinsmith shops is seen in this 1967 northwestward view. In the foreground, one of the inspection pits is sunk between the rails. In the right and center foreground, constructed of diamond plate, are several fuel-, oil-, and water-loading racks for diesel locomotives. (Photograph by David Keller.)

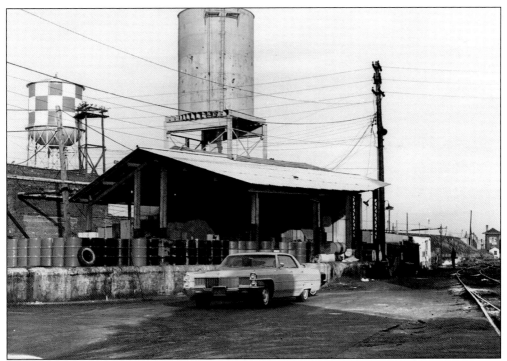

Located just southeast of the turntable is the oil house, pictured here in 1966. The high dock platform is full of 55-gallon drums containing various types of oil. To the left is the old engine dispatcher's office, and looming overall in the center is the shops' water tower. In the right background, Dunton tower can be seen. (Photograph by David Keller.)

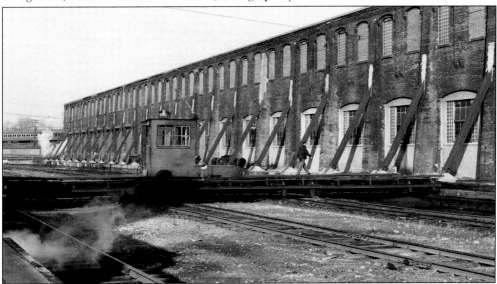

Looking north toward the Richmond Hill Storage Yard in 1966, this view shows the building housing the locomotive repair and machine shops. In the foreground is the transfer table that would access the many tracks within the building. It was upon this table that shop switchers such as class A1 No. 320 would ride. The doorways visible at the near end of the building have been closed up. (Photograph by David Keller.)

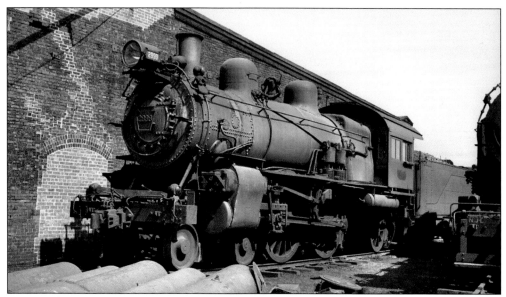

PRR E3sd class No. 2999, awaiting repair, lays up alongside one of the old brick shop buildings. Photographed in March 1940, this 1906 locomotive is missing its pilot, and the road number under the cab window has been painted over. The tender bears a full load of coal, however, so it is unknown how involved the repairs will be. (H. Forsythe Collection, David Keller Archive.)

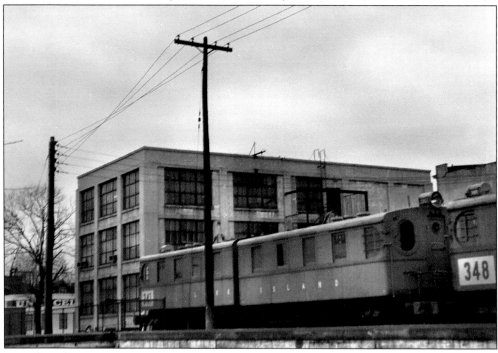

DD1 class electric locomotives No. 341 and No. 348, in the Tichy color scheme, are temporarily stored alongside the depressed tracks of the Atlantic branch at the Morris Park Shops on this gray day in January 1952. In the foreground, the concrete abutments and the top of the tunnel portal are visible. Looming in the background is the three-story general office building housing the Maintenance of Equipment Department. (David Keller Archive.)

Built in the fall of 1944 as the replacement coaling tower, this structure became the sanding tower once LIRR steam service had ended. During the diesel era, this concrete tower provided the locomotives with sand, which was used to provide traction to their wheels. In this eastward view, a string of units lays up on Christmas Day 1971. In the foreground is an inspection pit. (Photograph by David Keller.)

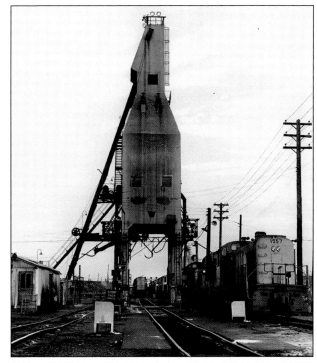

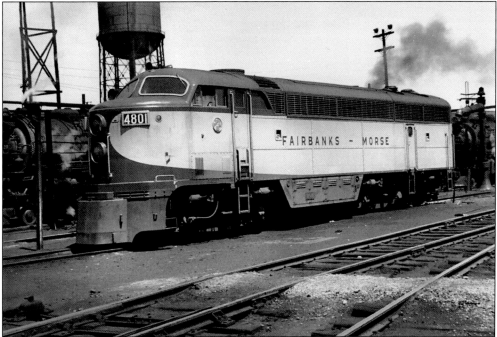

In May 1950, the old standby G5s class locomotives rest in the background while one-month-old Fairbanks-Morse demonstrator unit No. 4801 has arrived to be test driven. This model CPA24-5 unit would be in LIRR service from May 1 to June 26, 1950. Liking its performance, the LIRR would then purchase four of this model and eight of the CPA20-5 units. (Photograph by Frank Zahn.)

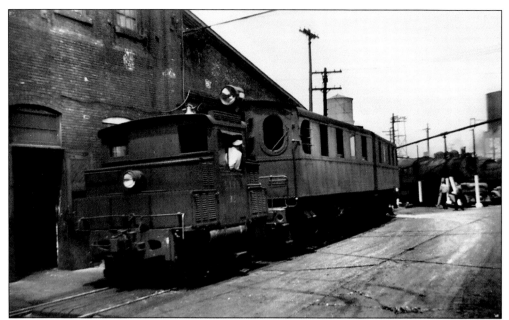

Class A1 electric shop switcher No. 320 pushes a DD1 electric locomotive past the locomotive and machine shops and toward the turntable in this c. 1946 scene. The engineer wears the typical LIRR-style cotton cap of hickory-striped crown and solid blue visor and band. The little switcher was built by Baldwin in November 1926 and remained in active service until its retirement on December 23, 1958. (Photograph by William J. Brennan.)

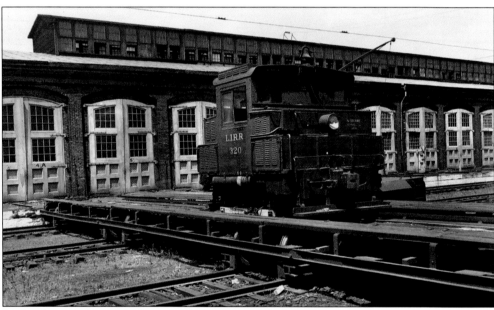

In this June 1949 view, looking northwest, A1 switcher No. 320 is on the transfer table in front of the passenger car shop building. The transfer table is operated by an overhead electric line that was connected by trolley pole, as seen above the engine at right. This scene nicely displays the many old wooden double doors. (Photograph by George E. Votava.)

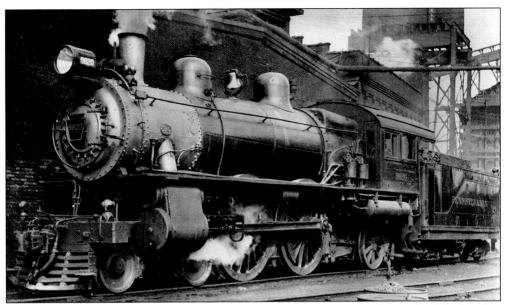

Laying up alongside the roundhouse, with both a full head of steam and a tender full of coal, is PRR-leased Atlantic class E7s (4-4-2) No. 9820. Built by the PRR's Juniata Shops in July 1906 as a class E2b, it was later rebuilt to a class E7s. With 80-inch drivers, it was a fast locomotive. The water and coaling towers are visible in this March 1937 scene. (George E. Votava Collection.)

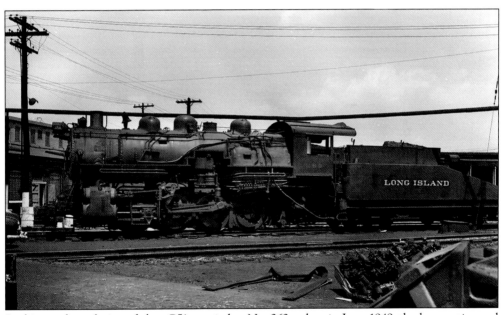

In this northward view of class C51sa switcher No. 262, taken in June 1949, the locomotive and machine shops appear in the left background and the roundhouse in the right background. This engine, a product of Alco (Schenectady), was built in August 1922. It had 56-inch drivers, and its wheel arrangement of 0-8-0 allowed maneuverability for switching. It was retired in 1949. (Photograph by George E. Votava.)

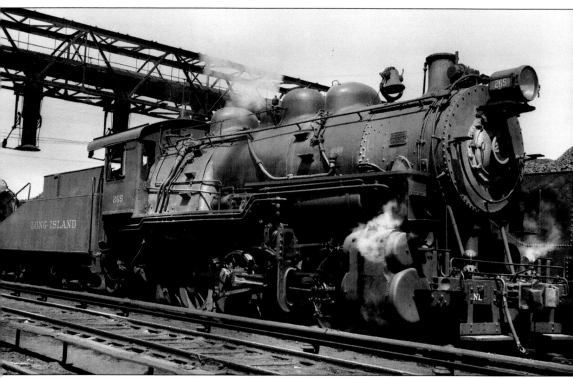

Residents who lived near the Morris Park Shops complained about the constant smoke in the air from the idling locomotives laying up at any given time of day or night. As a result, the smoke washer was installed in 1914. Locomotives were positioned under the stacks suspended from the support structure, the cones lowered, and the sooty, black smoke "washed" by jets of steam. Clean, white smoke then blew out the top of the washer, as the impurities poured out the bottom. Curious, though, are the number of photographs of the washer without locomotives actually positioned under a stack! This c. 1938 view looks northwest toward the smoke washer. In the foreground is C51sa No. 265. Behind the engine is class H6sb No. 309. The smoke washer mechanism was removed in the spring of 1945, and the support bridge was demolished in July 1946. (David Keller Archive.)

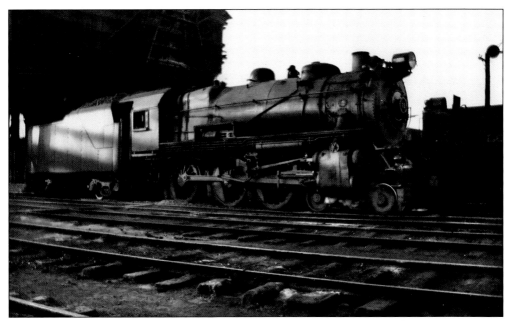

In June 1939, G5s No. 32 is backlit with sunlight peeking out from under the 1911-era wooden coaling tower at the Morris Park Shops. This view is looking northwest. In the foreground, the railroad ties and ground are well covered with many layers of oil that has dripped from engines laying up on these tracks for decades. (H. Forsythe Collection, David Keller Archive.)

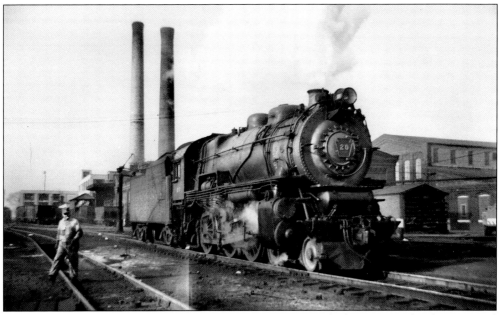

In this c. 1949 view, looking west, G5s No. 20 sits on a track that goes under the new coal dock. In the background are, from left to right, the Maintenance of Equipment office building, warehouse No. 1, the power plant with twin stacks, and peeking out from behind the locomotive, the blacksmith shop. The locomotive and machine shops are at right. (David Keller Archive.)

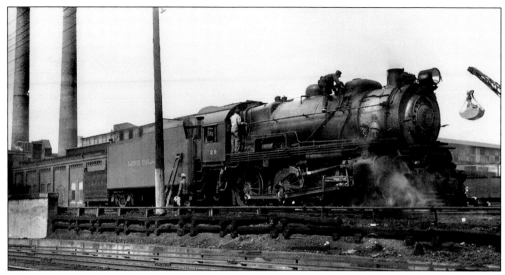

G5s No. 28 is under repair in this scene from April 1946. This northwestward view shows the twin stacks of the power plant, the blacksmith shop, a Pennsylvania Railroad tender visible behind the tender of No. 28, and the boom of a rail crane with a clamshell bucket at the right. In the foreground, the Atlantic branch tracks enter and exit the tunnel under Atlantic Avenue. (H. Forsythe Collection.)

In the locomotive shop, workers repair Alco RS3 No. 1554 in this scene from a 1966 special invitation open house held at the Morris Park Shops. The RS3's louvers and cowling have been removed on both the long and short noses, baring the whole inside of the unit. Hoisting or towing cables are hanging from the riveted steel column at the right. (Photograph by Norman Keller.)

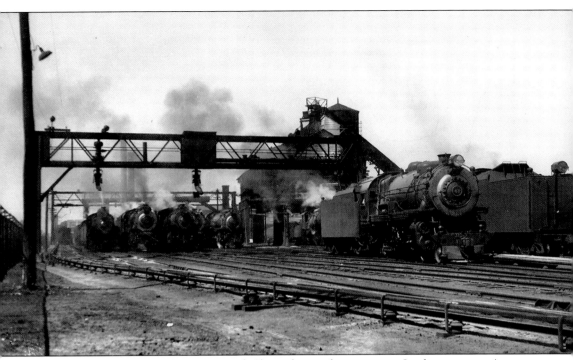

This is a typical scene at the Morris Park Shops during the steam era. Looking west in August 1938, this view shows G5s No. 43 laying up in the foreground. At the left is the fence paralleling the Atlantic branch, and behind No. 43 is a freestanding water plug, as well as the watering bridge with suspended spouts. Beyond that, a row of locomotives lays up under the smoke washer bridge. In the background is the old wooden coaling tower, with the conveyors and main water tower beyond. The lineup of equipment consists of a class DD1 electric locomotive in the distance, followed by steam classes H6sb, G5s, C51sa, and two more G5s class engines. The third rail in the foreground provided power to the DD1 locomotives stored along the fence at this time. (Photograph by William Lichtenstern.)

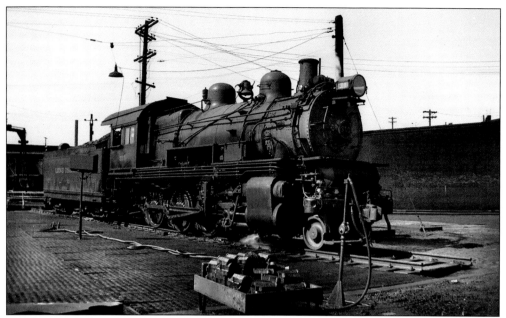

Freight Consolidation class H6sb (2-8-0) No. 310 lays up on one of the turntable garden tracks at the Morris Park Shops in August 1939. This sturdy locomotive was built by the Baldwin Locomotive Works in 1906 and had 56-inch drivers. Originally owned by the Pennsylvania Railroad and numbered 3571, it was acquired by the LIRR in 1916 and renumbered. It was retired in April 1948. (David Keller Archive.)

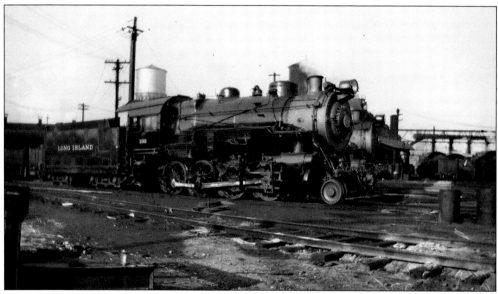

Apparently fresh from the paint shop, H10s (2-8-0) No. 102 sits on one of the turntable garden tracks at the Morris Park Shops in August 1939. Looking east, this view reveals the smoke washer at right. Originally built by and for the Pennsylvania Railroad in 1913, No. 102 had 62-inch drivers and was numbered 7174. It was acquired and renumbered by the LIRR and retired in December 1948 (H. Forsythe Collection.)

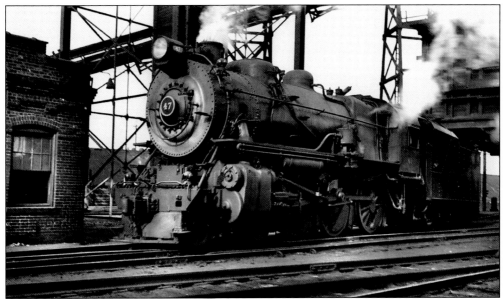

Still sporting classification lights atop the smoke box, G5s No. 47 lays up in front of the old wooden coaling tower at the Morris Park Shops in March 1940. The conveyor to the top of the tower is visible, as well as the Montauk branch embankment in the background. Built by the PRR's Juniata Shops in 1929, No. 47 had 68-inch drivers and was retired in August 1951. (David Keller Archive.)

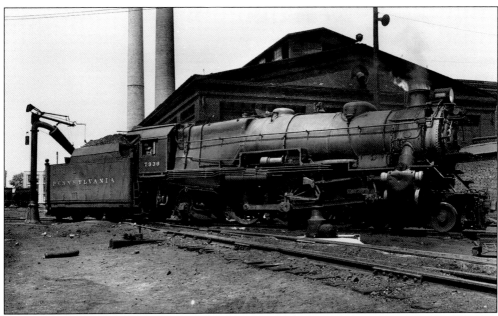

Sitting on the cross track in front of the Morris Park blacksmith shop, PRR K4s No. 7938 has just obtained a full load of coal and is now having a drink at the freestanding water plug in this June 1949 westward view. Constructed by the Pennsylvania Railroad in September 1918, this Pacific class locomotive with 80-inch drivers was scrapped in March 1950. (Photograph by George E. Votava.)

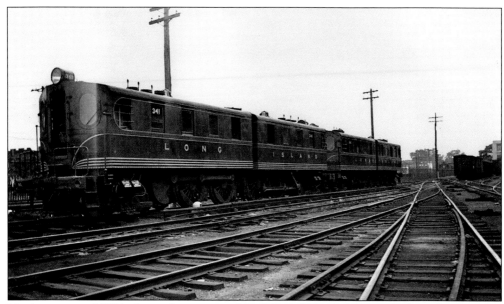

Newly pinstriped DD1 electric locomotives No. 341 and No. 343 are parked on the DD1 lay-up track at the Morris Park Shops in August 1939, when it was located alongside the Atlantic branch, separated only by a chain-link fence. A third rail was run along this perimeter track to power these locomotives. In 1944, a new DD1 lay-up yard was placed in service alongside the Montauk branch embankment. (David Keller Archive.)

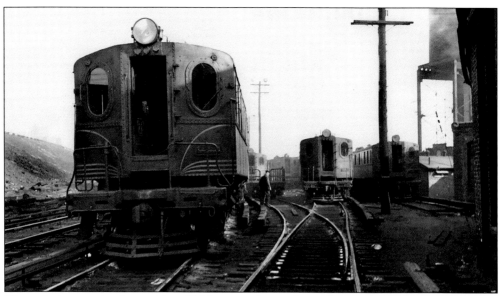

Through the morning haze, this c. 1946 eastward view shows the newer DD1 lay-up yard at the Morris Park Shops. Visible here are the Montauk branch embankment at left; an LIRR keystone logo on the open front door of the nearest DD1; an idler, or reach car, coupled to the DD1 in the center; more DD1s laying up; and the water tower at right. (Photograph by Bob Lorenz.)

MU car No. 2618, pulled into the passenger car shop, has had its seats removed, possibly for re-covering in the upholstery shop. Temporary lighting has been strung along the ceiling of the car in this 1966 view. Built by Pullman-Standard in 1955, this car was classed MP72C and as such was a motor car with cab controls. (Photograph by David Keller.)

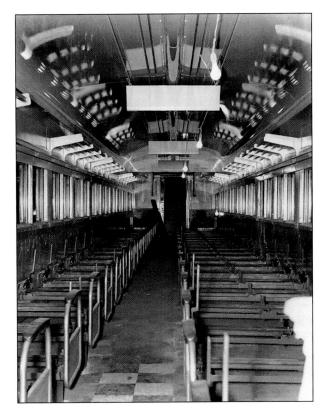

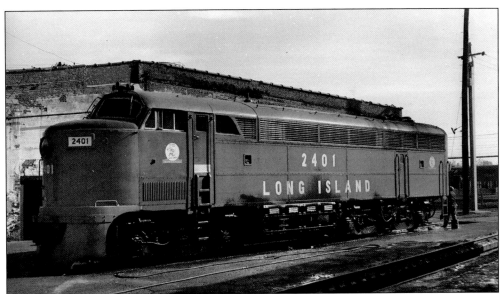

The lower portion of Fairbanks-Morse model CPA24-5 No. 2401 is sprayed with a type of lube as it sits over a maintenance pit in the gap between the two halves of the old brick roundhouse in August 1958. In the foreground is another pit, with track continuing toward the old electric yard behind the shops. In the background, oil drums are visible at the oil house. (David Keller Archive.)

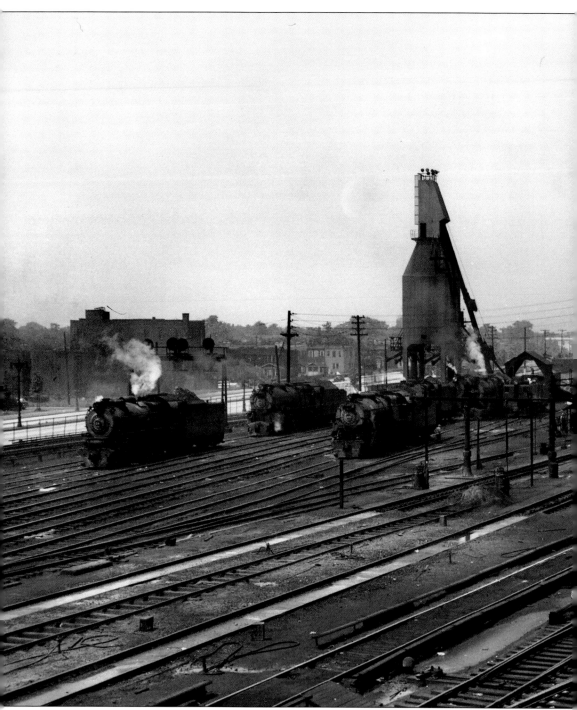

Standing on the Montauk branch embankment and looking southwest, the photographer has captured a panorama of the Morris Park Shops. At the far left is Atlantic Avenue; a G5s locomotive releases steam. Behind it are a bunch of PRR K4s locomotives. All the engines have just been coaled by the newer coaling tower behind. It is July 1950—just one year before the leased PRR units would go permanently back to the parent road. To the right of the locomotives

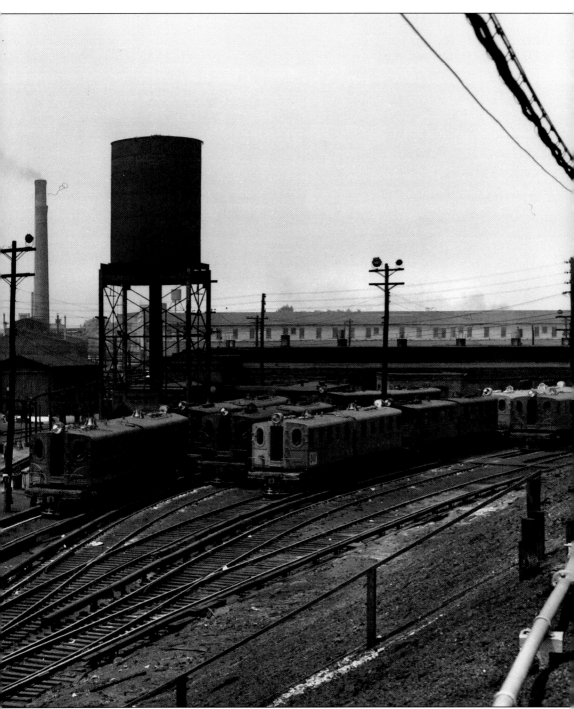

is box cab No. 402. In the center background are the stacks of the powerhouse, and in the center foreground, the water tower and roundhouse. To the right, the DD1 lay-up tracks are filled with electric locomotives in a mix of both the Tichy color scheme and 1939-era pinstripes. In the right background are the locomotive and machine shops. (Photograph by George E. Votava.)

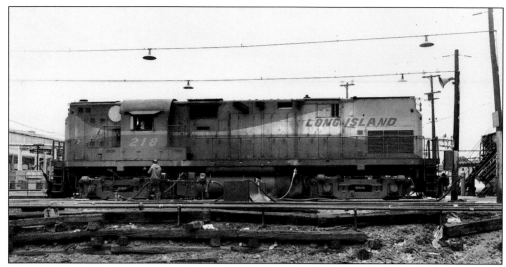

On this dreary, chilly day in May 1970, the engineer relaxes on his armrest as a worker in winter hat and sweatshirt waters and fuels Alco C420 No. 218. The huge diesel fuel storage tanks are located between the front and rear trucks. The view, looking north, shows the locomotive shops at left and the stairs for the sanding tower at right. (Photograph by F. R. Kern.)

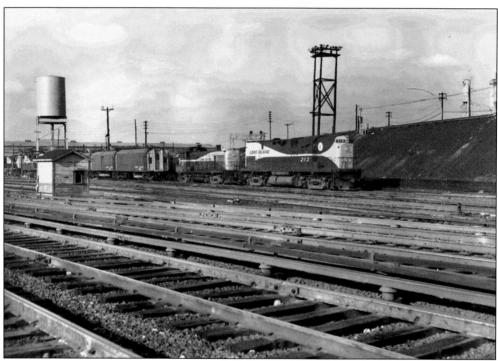

Looking northwest toward the Morris Park Shops and the Montauk branch embankment in the background, this January 1966 view shows Alco units C420 No. 213 and RS3 No. 1557 laying up. In the foreground is a switchman's shanty, and to the right of it are some former express cars that have been converted for maintenance-of-way use. More C420 units are visible at the far left. (Photograph by Bob Yanosey.)

Seven
DEPOTS AND TOWERS ALONG THE RIGHT-OF-WAY

"Down by the depot" was an expression folks commonly used. Many towns had their own depot, whether it be a combination freight and passenger structure or separate, stand-alone passenger and freight buildings as needed. Following a few common designs and occasionally throwing in some unique ones, each depot was built based on funds available and the needs of both the railroad and the town it served. In some cases, depot size and style were based upon the generosity of a wealthy family residing in that town.

Depots handled the receipt and shipment of express, baggage, U.S. mail, LCL (less-than-carload) freight shipments, and even entire carloads of goods, as dictated by the customers served. Additionally, many depots served as the local gathering place for both adults and children to catch a glimpse of the local trains, catch up on the news of the day, weigh in on the ubiquitous depot scale, send a telegraphic message or two, or use the pay telephone service.

Also of extreme importance were the interlocking towers and cabins. In addition to the depots, they provided manually issued, hard-copy train orders that controlled the movement of the vehicles. Some of these towers survive to this day and provide interlocking of tracks and signals on the various branches they serve. The Long Island Rail Road is one of the few remaining Class 1 railroads still operating in this fashion of years gone by.

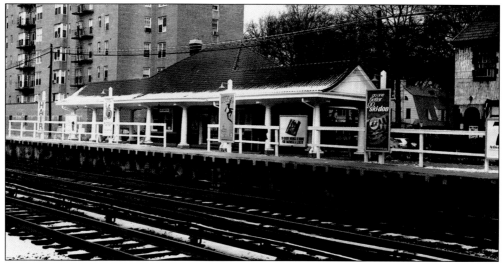

This view, looking northwest on a cold winter's day in December 1970, shows the Kew Gardens station in Queens. The depot is lightly dusted with snow, as are the safety boards covering the third rails. This little depot was opened on September 8, 1910, after the Maple Grove track realignment. Originally named Kew, it was renamed Kew Gardens after 1914. (Photograph by David Keller.)

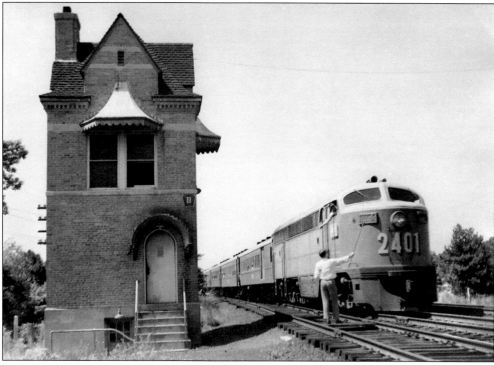

Fairbanks-Morse model CPA24-5 ("C-Liner") No. 2401 is headed east on the main line at B tower, Bethpage Junction, during the summer of 1952. The engineer's arm is outstretched to receive his orders from the Y stick of the block operator on the ground. This tower was placed in service in May 1936, replacing a wooden one demolished for the construction of the Bethpage State Parkway. (Photograph by Jules P. Krzenski.)

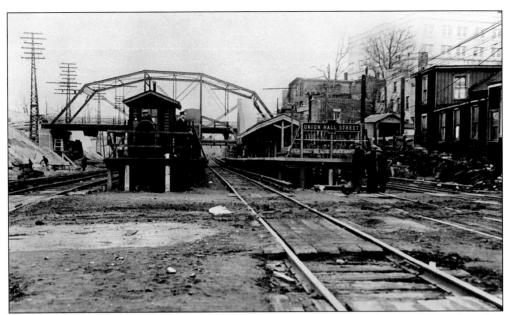

When the Jamaica station was elevated and moved westward in 1913, the LIRR opened another station at the old site to appease the inconvenienced residents. That station, located at Union Hall Street, is seen in this view, looking west from New York Avenue on December 16, 1929, prior to its elevation during the Jamaica Improvement East project the following year. Some construction is already under way at the far left. (David Keller Archive.)

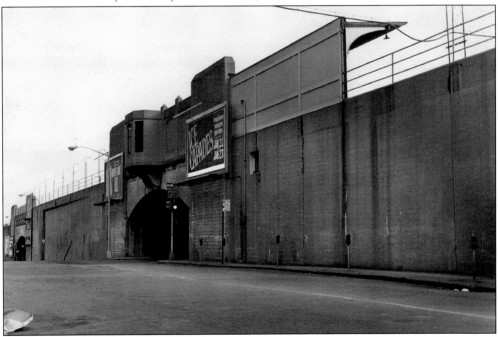

On a dreary Christmas Day in 1971, this view looks southeast at street level toward the rear of the westbound platform of the elevated Union Hall Street station in Jamaica. The bay window cantilevering out over the tunnel once housed the ticket office. This structure was elevated in 1930 as part of the Jamaica Improvement East project. (Photograph by David Keller.)

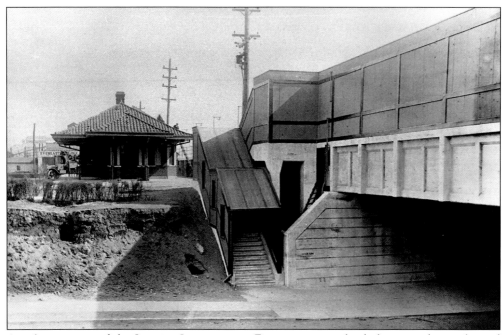

Another portion of the Jamaica Improvement East project involved elevating the tracks and providing new, high-level platforms at the Hillside station, located just east of Union Hall Street. The depot is shown here with a new bridge and stairs to access the platforms in February 1931. The depot was built in 1911. Hillside was discontinued as a station stop in 1966. (David Keller Archive.)

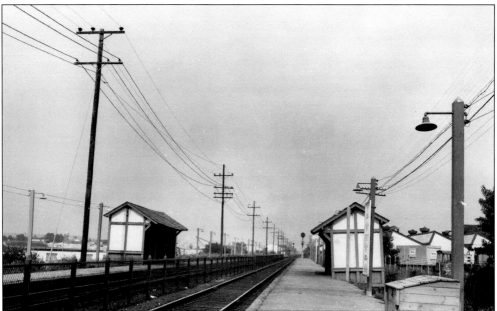

Built to service the employees of Republic Aviation in Farmingdale, the Republic station, viewed looking east in September 1970, was opened just east of the present-day Route 110 underpass in December 1940. Consisting of low platforms, electric light posts, and wooden shelter sheds, the station lasted until the 1980s. (Photograph by David Keller.)

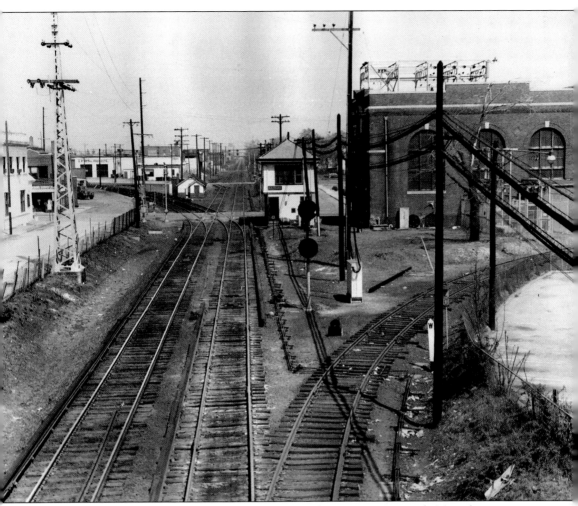

Looking east from the Mineola Boulevard overpass, this 1966 view reveals Mineola junction. Seen here are, from left to right, the tracks of the Oyster Bay branch curving to the left, the section shanty beyond, the tracks of the main line straight ahead, Nassau tower trackside, the LIRR's brick electric substation behind the tower, and the freight-only tracks curving off to the right toward Garden City. (Photograph by David Keller.)

An example of the LIRR's attempt at streamlining in the mid-1960s is shown here at Holbrook. Many depot buildings without agencies were razed as "maintenance-intensive" and were replaced by this type of metal shelter shed. This view looks east from the crushed-cinder platform toward the Coates Avenue crossing in May 1970. (Photograph by David Keller.)

This view of the ticket-block office at Central Islip was photographed around 1935. At left is the ticket counter with rubber stamps on the wall. In the center is the operator's desk built into the bay window. Visible here are the Y order sticks, table block machine, and dispatcher's flexi-phone. At right is the agent's desk. Flypaper hangs at the windows. (Photograph by George G. Ayling.)

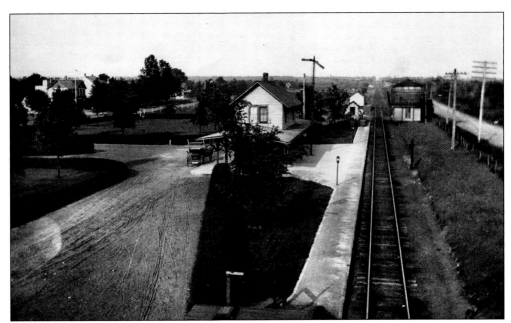

While this photograph of Ronkonkoma was taken in 1915 from the new Ronkonkoma Avenue trestle, little had changed by the 1920s and 1930s until the depot burned in 1934. The landscaping was funded by Maude Adams, Broadway star and resident of this town. In the foreground is the express platform and scale. In the distance are the eastbound express house, freight house, and water tower. (Photograph by Thomas R. Bayles.)

It is 1940 and the trees have grown at Ronkonkoma. In this eastward view from the Ronkonkoma Avenue trestle, the new 1937 depot is just visible at the left, as are the express and freight houses. In the distance, trackside at right, are the water plug and KO cabin. At left, a G5s locomotive pulls its train from the yard. The water tower is hidden behind the trees. (Photograph by T. Sommer.)

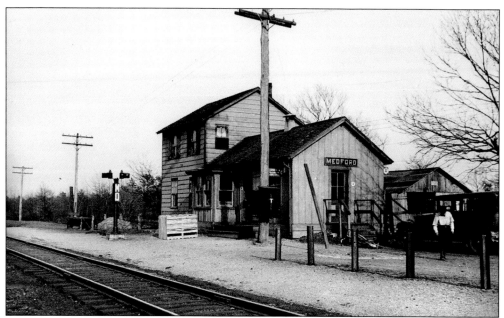

By April 1940, the days of the old Medford depot were numbered. The 1889 structure would soon be demolished during the grade elimination of Route 112. At left are the baggage wagon and the MD block limit station signals. A crated item awaits the next express car. On the telephone pole is the T-box housing the LIRR's magneto phone. Old rails serve as platform bumpers. (Photograph by Albert E. Bayles.)

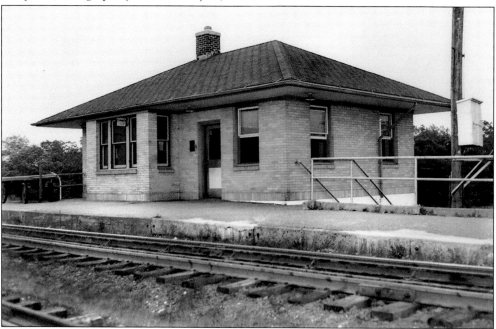

From almost the same angle, the elevated Medford station, opened in November 1940, is seen in September 1958 at the end of its agency. The brick structure with the express office at ground level would be severely vandalized and demolished in 1964, leaving the lower portion with blocked windows to stand for another 30 years. (Photograph by Irving Solomon.)

A rear view of the elevated Medford station shows both the ticket office and waiting room at the upper level and the express office at the lower level. At right is the beginning of the express ramp to track level. Photographed in 1960, the agency had already been closed for two years; however, it appears that there was still life in the express office. (Photograph by Thomas R. Bayles.)

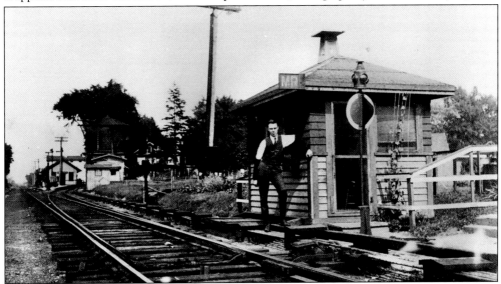

Manorville was the junction of the main line with the tracks that connected to the Montauk branch at Eastport. Controlling this junction was MR cabin, depicted in this c. 1925 eastward view with block operator James V. Osborne. In the distance are the Manorville depot, water tower, and tracks curving off to Eastport. Opened in August 1916, the cabin was removed along with the junction and wooden depot in 1949. (David Keller Archive.)

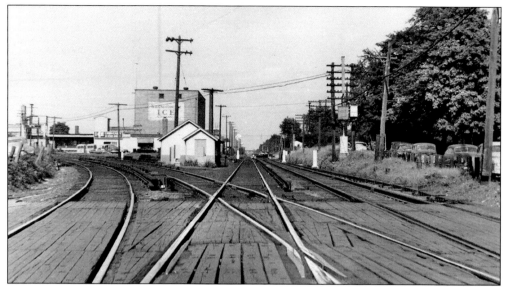

This 1952 view looks east along the main line from in front of Nassau tower in Mineola. In the foreground is the old-style planked crossing of Main Street. The tracks curving off to the left are headed toward Oyster Bay, and in the middle of the junction is the old section shanty. Beyond the shanty is the Knickerbocker Ice Company, a once frequent sight on Long Island. (Photograph by J. P. Sommer.)

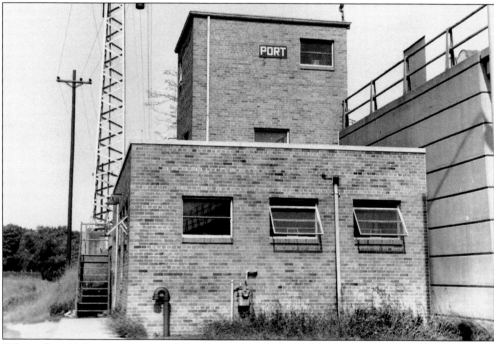

When the old Port tower east of Freeport was withdrawn from service in May 1959 due to the elevation of tracks in the grade-elimination project, a newer brick structure replaced it. Placed in service on October 11, 1960, it was located on the north side of the tracks and east of the Freeport station. Photographed in 1968, the new tower ended service on May 16, 1983. (Photograph by David Keller.)

The mail crane was a typical structure along the right-of-way. Found at all stations where an agency was located, the crane would be pulled down and the mailbag of the U.S. Postal Service attached. An RPO car would then come along at speed, as in this scene at Central Islip around 1930, and with doorway bar swung out and locked in place, would yank the mailbag off the crane. The mail would then be sorted along the route by postal clerks. The mailbag would be tossed off the moving train as well. A small, trackside slat fence was usually constructed to prevent the bouncing bag from going back under the wheels of the train. (Photograph by George G. Ayling.)

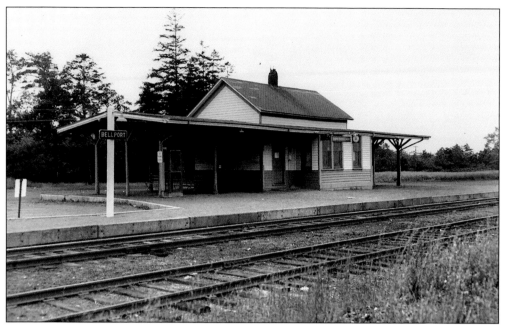

It is September 20, 1958, and the LIRR prepares to close the agency at the 1882 Bellport depot. Looking southwest, Irving Solomon has photographed the structure for the Public Service Commission. The agency would end in January 1959. In view here are signs for American Telephone & Telegraph, Western Union, and Railway Express Agency, as well as a U.S. mailbox under the covered platform, indicating a once busy agency. The depot was razed on September 22, 1960.

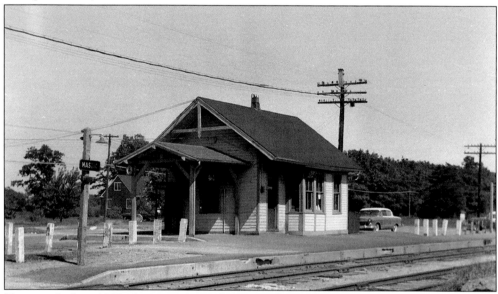

Photographed in 1955, the tiny Mastic depot stands on the northeast side of Mastic Road. Opened in 1882 as Forge, it was renamed with the town in 1893, though the telegraphic call of the block signal remained F years later. Mastic was discontinued as a station stop when the agency moved west to the newly opened Mastic-Shirley station in July 1960. The old depot was destroyed one month later. (Photograph by Rolf H. Schneider.)

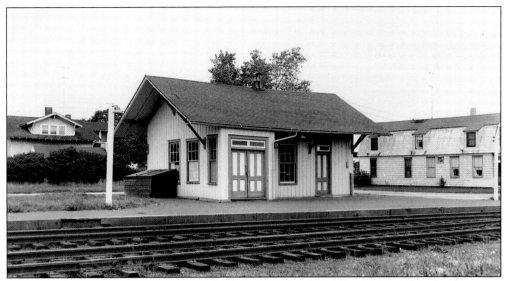

Originally built as the Moriches station on the Sag Harbor branch in March 1870, this depot was moved eastward to this site on the Montauk branch the night of October 18, 1881, becoming the Eastport station. It appears the agent's bay was remodeled into a freight office some years later. Seen here in September 1958, the stop was about to be discontinued. The depot was sold and relocated in 1959. (Photograph by Irving Solomon.)

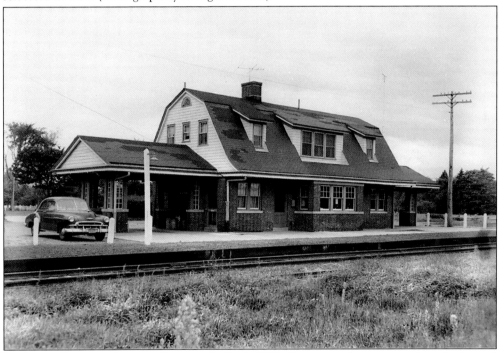

Replacing the original station destroyed by fire in 1910, the second Amagansett depot is pictured in this view, looking southwest in September 1958, when the agency was about to close. In June 1942, Nazi spies, offloaded by U-boat offshore, caught the train from here to head into Manhattan. They were later arrested when their spy network was exposed. This beautiful depot was razed in August 1964. (Photograph by Irving Solomon.)

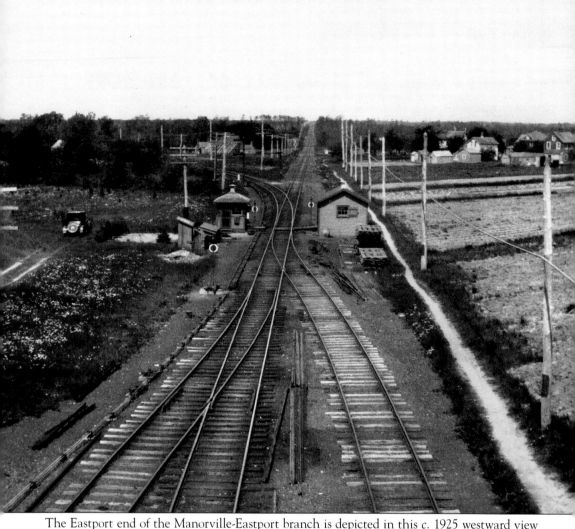

The Eastport end of the Manorville-Eastport branch is depicted in this c. 1925 westward view from the signal mast. Straight up the Manorville branch are PT cabin at the left, the Montauk branch curving off to the left beyond the cabin, and a section shanty opposite PT. The site of the original Moriches station was just past the very last telegraph pole on the right, seen in the distance. Placed in service in 1916, PT was opened summers only after January 1933 and was withdrawn from service in September 1942. The cabin was removed by 1949, along with the junction. (Photograph by James V. Osborne.)

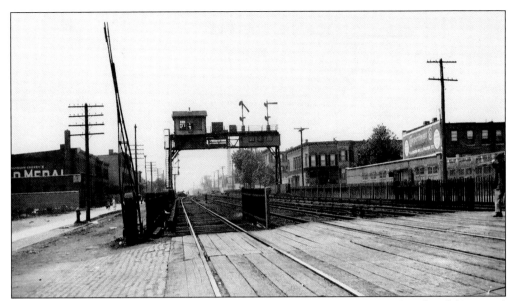

CN tower, located atop a signal bridge on the Atlantic branch just west of Railroad (Autumn) Avenue in East New York, is shown in this c. 1925 westward view. "CN" stood for Chestnut Street Junction, the designation dating back to the period of joint operations between the LIRR and the Brooklyn Rapid Transit. In service in 1922, this tower was later renamed Autumn and lasted until 1928. (Photograph by James V. Osborne.)

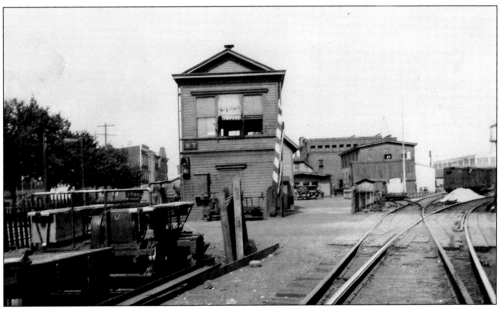

WT tower, along the Atlantic branch, controlled Woodhaven Junction when the tracks were at grade. Looking east around 1925, this view shows the Atlantic branch tracks at left, behind the picket fence. The depot is partially visible to the right of the tower, behind the cars, and the tracks to the Rockaway Beach branch curve off to the right. A stubby crossing gate protects the station parking lot. (Photograph by James V. Osborne.)

The Wading River extension was only a recent memory when this photograph was taken in 1939. After the last revenue train ran on October 9, 1938, and the branch abandoned on March 29, 1939, the tracks were taken away, and now a demolition crew removes the Miller Place Road 1895 wooden trestle from over the right-of-way, east of the former Miller's Place station site. The remaining wooden ties would soon be the only evidence of rail activity east of Port Jefferson. (Photograph by Albert E. Bayles.)